# THE J. PAUL GETTY MUSEUM
# · GUIDE ·
## TO THE VILLA AND ITS GARDENS

THE J. PAUL GETTY MUSEUM
MALIBU · CALIFORNIA
1989

© 1988, 1989 The J. Paul Getty Museum
17985 Pacific Coast Highway
Malibu, California 90265

Mailing address:
P.O. Box 2112
Santa Monica, California 90406

(213) 459-7611 administrative offices
(213) 458-2003 parking reservations

Christopher Hudson, head of publications
Andrea P.A. Belloli, editor-in-chief
Patrick Dooley, art direction and design
Thea Piegdon, production artist
Karen Schmidt, production manager
Elizabeth Burke Kahn, photograph coordinator

Typography by Andresen Typographics, Tucson, Arizona
Printed by Nissha Printing Co., Ltd., Kyoto, Japan

This publication involved the participation of numerous
people over a period of years. "The Museum in Context"
was written in 1987 by John Walsh. "Rediscovering the
Villa dei Papiri," "A Walk through the Museum and
Its Gardens," and the narrative captions represent
contributions by Andrea P.A. Belloli, Elizabeth Burke,
Stephen Garrett, Benedicte Gilman, Anne Kresl, Sandra
Knudsen Morgan, Norman Neuerburg, and Michaeline
Sweeney, as well as other staff members, scholars, and
friends of the Museum whose invaluable contributions are
too numerous to acknowledge individually.

Library of Congress Cataloging-in-Publication Data
J. Paul Getty Museum.
    The J. Paul Getty Museum guide to the villa and its
gardens.
        p. cm.
    ISBN 0-89236-081-X
    1. J. Paul Getty Museum—Guide-books. 2. Gardens—
California—Malibu—Guide-books. I. Title. II. Title:
Guide to the villa and its gardens.
N582.M25A83    1988                          88-2199
708.194'93—dc19

# CONTENTS

# FOREWORD

For a long while our visitors have needed an illustrated guide to the Museum's remarkable building and gardens. Norman Neuerburg's *Herculaneum to Malibu* (1975) is long out of print, and his detailed personal account published in *Classical America* 4 (1977) never had wide circulation. We hope that this guidebook, which is a companion to the *Handbook of the Collections,* will begin to satisfy the curiosity of the many thousands each year whose awareness of Roman domestic architecture begins with a visit to the Getty Museum, and who want to know why and how the villa and gardens took their distinctive forms.

Our newly appointed Editor-in-Chief, Andrea P. A. Belloli, inherited this longstanding project and has guided it through the press at last. Imbedded in the text are contributions by many people, including my predecessor Stephen Garrett. We owe the greatest debt, however, to Norman Neuerburg, the archaeologist who guided Mr. Getty's architects in their reinvention of a Roman villa, and who has been generous in helping us to document and understand the building more fully. It is to Dr. Neuerburg that this guidebook is gratefully dedicated.

John Walsh
Director

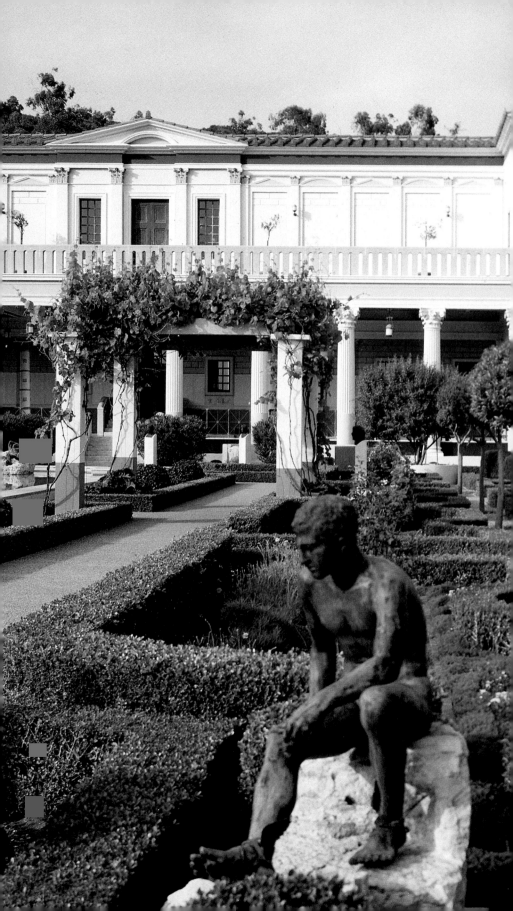

# THE MUSEUM IN CONTEXT

The building that houses the J. Paul Getty Museum—a reconstruction and adaptation of the Roman Villa dei Papiri at Herculaneum, which was buried by the eruption of Mount Vesuvius in A.D. 79—is as fascinating in its own way as the collections it houses. This book aims to introduce the reader not only to the Museum building but to its model, its roots in Roman domestic architecture, its forms and materials, and its makers. In the years since it was finished, the Museum has been the subject of a revealing critical controversy, so a few words will be said about the short but interesting history of the building. The reader may also be curious as to why Mr. Getty built it and about the tradition of revival architecture to which it belongs.

The polemics of the mid-1970s about the Museum make interesting reading today. When it opened in 1974, it was treated with general amazement by the press. Many were scornful; some Los Angeles writers were embarrassed as well. A minority of journalists and serious architectural critics was pleased. (There was never any doubt about the affections of the lay public, which voted with its feet and cars, temporarily overwhelming the Museum and the surrounding residential neighborhood. The press of visitors required development of a reservations system that is still in use.)

Mr. Getty was not shy in expressing his feelings about modern architecture. He clearly wanted nothing to do with a "tinted-glass and stainless-steel monstrosity" or "one of those concrete bunker-type structures that are the fad among museum architects." Mr. Getty was bucking the modernist orthodoxy of the late 1960s which, though it was showing some strains, had nevertheless survived pretty well intact for most of his lifetime. Predictably, at the time the Museum was planned and constructed, his idea of re-creating a Roman villa struck most critics

---

*A seated bronze statue of the messenger god, Hermes, at rest evokes the tranquil atmosphere of the J. Paul Getty Museum and its gardens. The two-story building housing the Museum, visible here at the end of a path through the Main Peristyle Garden, re-creates the country retreat of a wealthy citizen of ancient Rome. Mr. Getty's aims in building a new museum in Malibu clearly included a desire to enable visitors to enjoy the ambience of an ancient building while viewing works of art from the past. "I thought it worthwhile to create one building in the Roman tradition," he explained.*

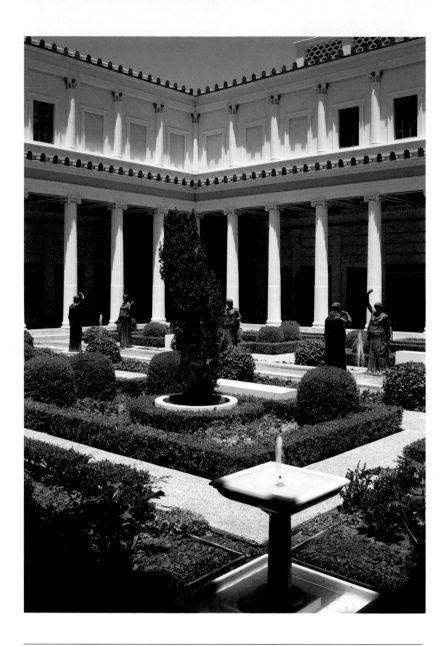

*The Museum embraces and is surrounded by gardens intended to evoke those of a typical Roman villa. Thus it is possible to see how such an ancient domestic structure interacted with its man-made and natural surroundings. The symmetrical plantings in the enclosed gardens—here the Inner Peristyle and Main Peristyle gardens may be seen—are geometric in layout, but the low, gentle curves of the topiary plantings provide a softening effect. Oleander, ivy, and box hedges dominate the ensembles; vine-covered trellises occupy focal positions in the Main Peristyle Garden. The statues and busts in all of the gardens are casts of sculptures discovered during explorations of the Villa dei Papiri.*

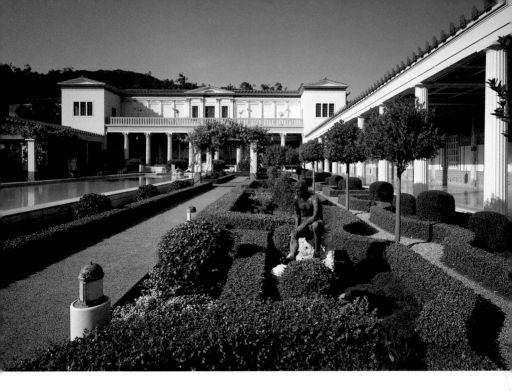

as whimsy at best, folly at worst. Less imaginative writers condemned the Museum by adding it to the list of familiar local insults to cultivated taste: the genial make-believe of Disneyland, the flimsy historicism of *Ben-Hur* sets, or the eclectic ersatz of Beverly Hills houses and restaurants. It was said repeatedly that sixteen million dollars should have bought a distinguished modern building that would have advanced the art of architecture, not set it back. Besides, a few writers claimed, the Museum building wasn't a correct reconstruction but a faulty pastiche. Others complained that it was *too* correct, but they differed on the symptoms. What some saw as bloodless fussiness others took to be gaudy vulgarity.

Everybody, including Mr. Getty, agreed that the Museum was a building that pleased the lay public. A few subtle minds drew interesting conclusions from this idea. Joan Didion thought the building affronted the critic and pleased the layman because it reminded them both that rich Romans did not live in the mellow austerity of our dreams of antiquity but in colorful ostentation. Thus for her the Museum was "one of those odd monuments, a palpable contract between the very rich and the people who distrust them least." Earlier, the architectural historian David Gebhard had seen the Museum as successful populist architecture. All designers have models, he wrote, whether they know it or not. He asked, "[E]ven if a case could be made that ethics and design are somehow related, why is it reprehensible to employ forms of the distant past, rather than borrowed forms of the near past?" This question, provocative in

1974, is hardly asked any longer. The debate now has shifted from *whether* such borrowings are legitimate to *what* forms should be borrowed, and how, and on what basis. Meanwhile the Getty Museum, in one of the breathtaking ironies of modern architecture, has gone from retrograde to prophetic.

Mr. Getty's decision to re-create the Villa dei Papiri may be easier to understand if we consider that it was no sudden whim of the late 1960s but the realization of a fantasy that had been in his mind for many years. A surprising side to this unfathomable man, so stolid and practical to all appearances, was a lively interest in history. He both mused upon the distinguished former owners of his works of art and pondered his own place in chronicles yet to be written. Other American businessman-collectors had a similar bent—about J. P. Morgan an embittered Roger Fry wrote, "A crude historical imagination was the only flaw in his otherwise perfect insensitivity"—but unlike the others, Mr. Getty was attuned to works of art and prone to writing down his flights of historical fantasy. In 1955, the year after the original Getty Museum was opened in his Malibu ranch house (just to the northeast of the present Museum), he published a novella called *A Journey from Corinth* in which the actual Villa dei Papiri figures. In the book a young couple emigrates from Corinth to Neapolis (ancient Naples) in the second century B.C. The husband, Glaucus, a landscape architect, enters the employ of Lucius Calpurnius Piso (an actual historical personage, father-in-law to Julius Caesar) at his great villa at Herculaneum. Mr. Getty's sketch of Piso has more than a little of the self-portrait about it: "one of the richest men in Italy...a pleasant looking Roman in his mid-thirties although a trifle pompous in manner." In Mr. Getty's account,

> Calpurnius Piso owned one of the largest villas in that part of Italy. Its buildings covered some ten acres, and its gardens extended along the sea-coast for over half a mile. Piso was born in Rome, the only child of a very rich father who was now Consul. He had hoped to make a career for himself in politics, but after a brief experience decided that he possessed little political ability; and since he was a man of great wealth, would be better out of political life than in it. Subsequently he left Rome, bought some two hundred acres of land on the Bay of Naples—adjoining the little village of Herculaneum—and in recent years occupied his time building this great villa. The work had progressed well. Only some of its gardens remained to be completed.

Glaucus is hired and does great work for Piso. Later in the story Corinth is captured by the Romans and sacked. A vast trove of works of art is removed to Italy, and an auction is arranged in Neapolis. (The parallel with Mr. Getty's own first purchases at auction for bargain prices in Europe during the Depression is too close to miss.) At the sale Lucius Calpurnius Piso forms the beginning of an important collection with the advice of

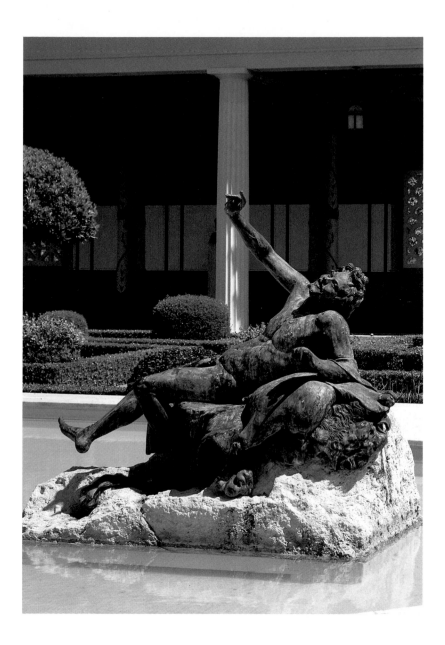

This statue of a drunken faun is a replica of a sculpture that was placed in antiquity at the head of the large pool in the main peristyle of the Villa dei Papiri. The original is considered to be one of the finest large bronze statues to have survived from antiquity. The artistic importance of this statue was already recognized in the eighteenth century, when the first systematic exploration of the towns buried by Vesuvius began.

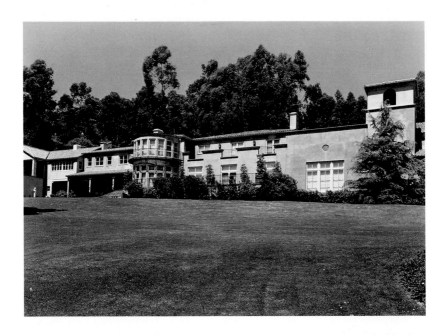

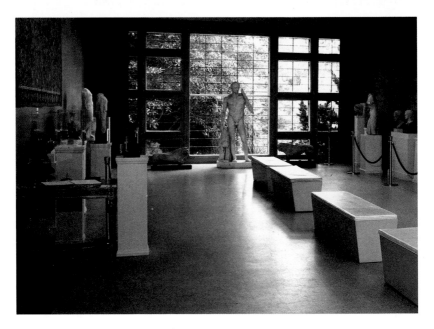

*Before the present Museum was built, Mr. Getty's collections of Greco-Roman antiquities, French furniture and other decorative arts, and old master paintings were housed in the ranch house illustrated above, which was located near the top of the small canyon in which the present Museum stands. In the house, which today is used for staff offices, the Lansdowne Herakles, seen here at the far end of the original antiquities gallery, occupied a prime location.*

Glaucus. Among other things he buys the Lansdowne Herakles (Mr. Getty's favorite possession and a highlight of the Museum's collections— but certainly never owned by Piso), which in Mr. Getty's fable had stood earlier in the agora of Corinth. The statue is then proudly installed by Piso in the Villa dei Papiri, is later given to Nero, and then passes to the emperor Hadrian—the other notable villa-builder whom Mr. Getty admired and with whom he identified himself. In a kind of afterword to his romance, Mr. Getty records that the statue finally made its way to England and then "followed the sun westward to the New World."

It is worth noting that Glaucus got the job at the Villa dei Papiri only after Piso asked him many questions and finally said, "[Y]ou seem to have a flexible mind. If you understand that I mean to have my own way in landscaping, and you wish to act as my assistant and further my efforts, instead of trying to thwart them, you and I should get along very well." It is as though Mr. Getty were warning his future architects. Had they read his book, his advisers might have been less astonished some dozen years later by his command to reconstruct the Villa dei Papiri.

If the reborn villa embodies Mr. Getty's fantasies about the men he thought of as his antecedents in imperial Rome, it also continues several important architectural traditions. These have little to do with Los Angeles, let alone Disneyland, but a good deal to do with European and American practice of the past century.

The notion of putting an art collection into an elaborate house designed partly for that purpose seems to have been a Roman invention, and indeed the original Villa dei Papiri, like many other country houses, was a kind of private museum. In the villa the owner and his guests, having escaped the business of the crowded city, could refresh their senses and their intellects. Sculpture, portable paintings, and murals were placed where they could give delight in concert with the gardens, peristyles, fountains, vistas through rooms, and other pleasant contrivances of the builder. By adapting a villa for his collection, Mr. Getty was reviving an older and purer form of the house-as-museum, a type he knew especially well in his adopted home of England, which abounds in the house-become-museum, in the city (the Wallace Collection in Hertford House, the Wellington Museum in Apsley House) or outside it (the Iveagh Bequest at Kenwood, and innumerable others).

As Mr. Getty clearly realized, several generations of American millionaires had installed their art collections in newly built palazzi and great houses, whether Venetian (Isabella Stewart Gardner in Boston), French (Henry Clay Frick in New York), Spanish (William Randolph Hearst at San Simeon), or English (Henry E. Huntington in Pasadena). One of these, John D. Rockefeller, Jr., had made a specialty of sponsoring historical reconstructions for museum buildings. Rockefeller did this on a grand scale, putting a sizable part of his oil fortune into a series of projects that cannot have failed to impress Mr. Getty and feed his ruminations on

During the 1800s French artists and architects who won the Prix de Rome were sent to Pompeii and Herculaneum to draw views and plans of the ruins. Drawings like the one illustrated above show the ancient buildings both in their ruined state and in reconstruction, as well as the brilliant hues of freshly excavated wall paintings. The invention of photography in the second quarter of the century offered yet another medium for the recording of ancient remains. Alfred Normand's 1851 calotype shows Pompeii's House of the Faun, which was to become a source of decorative details for the Getty Museum.

what he himself might build one day. One of the most successful of Rockefeller's projects, the Cloisters, is a group of buildings and courtyards ' in medieval style overlooking the Hudson River, a *musée d'ambiance* that evokes strong associations with a remote European past while providing all the modern conveniences. Just as suggestive for Mr. Getty the amateur archaeologist would have been the Stoa of Attalos II, an imposing two-story Hellenistic commercial building reconstructed between 1953 and 1956 from its foundations in the Agora of Athens with Rockefeller support. The stoa now serves as a museum containing works uncovered during the Agora excavations.

Roman villas as described by Vitruvius and Pliny the Younger have occupied the imaginations of architects since the Renaissance. And ever since the rediscovery of Pompeii and Herculaneum in the eighteenth century, there have been countless attempts to reconstruct the ancient houses there, if only on paper. Mr. Getty's interest in the subject was therefore nothing new. In fact, when he engaged Norman Neuerburg as historical consultant to re-create the Villa dei Papiri on the basis of archaeological evidence, Mr. Getty was reviving a tradition that had lapsed only recently after several centuries of vigor. Architecture students at the French academy in Rome were frequently required to submit drawings of buildings at Pompeii. These measured studies of the ruins and renderings of the buildings as "restored" in the imaginations of the architects are the direct antecedents of the Getty project. Called *envois,* they are reconstructions of Pompeiian houses hardly less elaborate than the Villa dei Papiri. The large, vividly colored drawings not only depict plans and elevations of entire reinvented building complexes but also give a vivacious account of bright murals, lavish decor, and precious details.

To succeed at the academy you had to know the hard evidence of the remains, and more: you had to try to think like a Roman architect. You had to know all the other comparable antique buildings so as to invent more confidently. The students' aim in these exercises was not so much a correct restoration as a plausible, harmonious pastiche. This was exactly the task of Dr. Neuerburg as he set about designing an adaptation of the Villa dei Papiri, which is known only from an incomplete ground plan of 1754, and whose elevations are for the most part a mystery. Naturally, the job was infinitely complicated by the purpose of the building: not to house a family and its possessions but to be an up-to-date public museum.

Had the Museum's circumstances remained the same after it opened, little might be different in the building today. But in 1976, when Mr. Getty died, he left an extraordinary bequest that opened up new possibilities. Whereas the collections had been limited in his time to Greek and Roman antiquities, French furniture and decorative arts, and European paintings, they now could be broadened to include sculpture and other European works of art, drawings, illuminated manuscripts, and photographs. To show all this without adding to the villa—not an easy building to

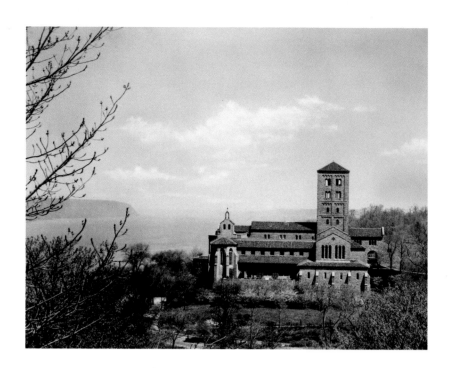

*Illustrated above, the isolated site of the Cloisters, in Manhattan's Fort Tryon Park, resembles the settings of many monasteries in medieval Europe. This museum is not a copy of a particular structure but rather an ensemble of gardens and spaces suggesting the ambience of monastic establishments erected in France during the Middle Ages. The construction of the Cloisters—from an assemblage of materials derived from actual medieval buildings—began in 1925 with funding donated by John D. Rockefeller, Jr., on a site given by him to the city of New York. The Cloisters thus differs from the Getty Museum in its reuse of structural elements from preexisting buildings. The photo on the opposite page shows the site of the J. Paul Getty Center, of which the new Getty Museum will be a part. The Palos Verdes peninsula and the beach at Santa Monica are visible at the upper right.*

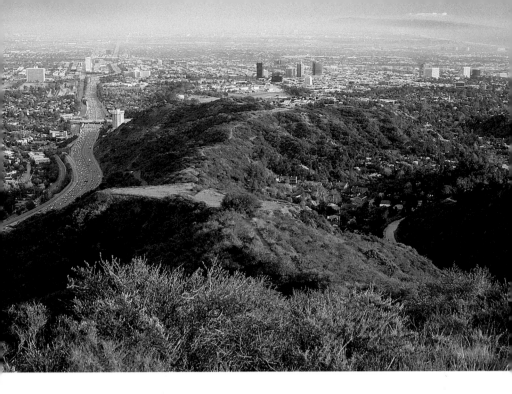

expand—has made it necessary to rearrange the galleries extensively. Just as the original Villa dei Papiri was altered by its successive owners over the years, so the interiors of the original ranch house and present Museum have been changed and changed again to accommodate the growing collections, staff, conservation facilities, and public services.

It soon became plain, however, that only another, larger Getty Museum could hope to do justice to the collections. Mr. Getty's legacy gave his Trustees the chance to create a group of organizations to benefit the fields of scholarship, conservation, and education in the visual arts and also allowed them to embark upon the construction of the J. Paul Getty Center to house these younger organizations of the J. Paul Getty Trust, to which the Museum's work is often closely related. All of them will be located with the new Museum in a complex of buildings scheduled to open in the 1990s. The 24-acre building site is part of a 110-acre tract on a spur of the Santa Monica Mountains in west Los Angeles. The new Getty Museum, which will house all of the collections except antiquities, will contain more than twice the exhibition space of the villa. After the new Museum opens, the present building will be refashioned to serve as America's only museum devoted entirely to Greek and Roman art, a function for which it is naturally suited thanks to the imagination of Mr. Getty and the skill of those who realized his vision.

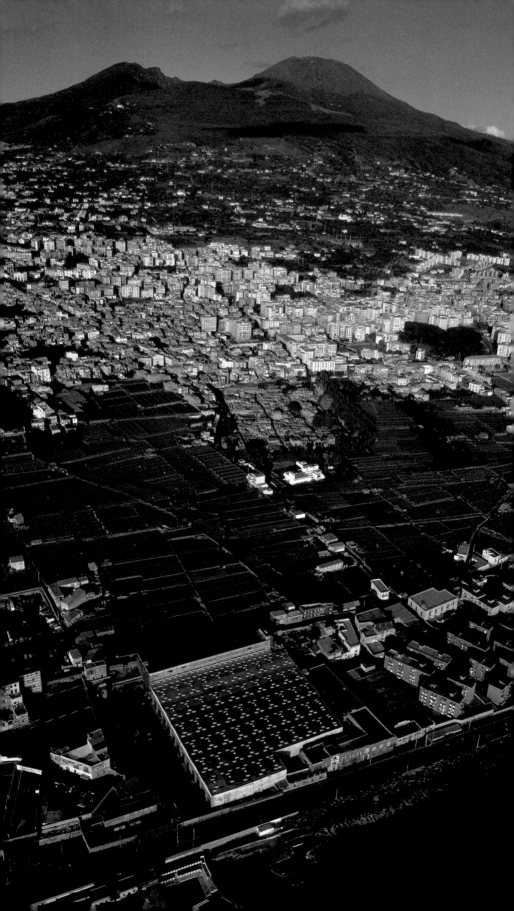

# REDISCOVERING THE
# VILLA DEI PAPIRI

The Villa dei Papiri stood in antiquity just outside the small, quiet
Roman resort town of Herculaneum, at the foot of Mount Vesuvius.
Slightly to the southeast lay Pompeii, a bustling commercial center with
a somewhat larger population of at least ten thousand people. The region
in which these cities were located, known as Campania and prized for
its fertility and mild climate, had become the favorite country retreat of
the Roman urban aristocracy by the first century A.D. Mount Vesuvius,
the great volcanic formation that loomed over the landscape, was not
considered a threat, since it was thought to be extinct. No one connected
the volcano with the severe earthquake that occurred in the region in
A.D. 63, and minor earth tremors, like those that preceded Vesuvius'
catastrophic eruption in A.D. 79, were common and caused no alarm.

The day on which this eruption began, August 24, was an official
holiday celebrating the birthday of the deified emperor Augustus and,
ironically, the feast of Vulcan, the Roman god of subterranean fire. At
about noon the volcano exploded. For twelve hours pumice and ash
rained down on Pompeii and the areas south of Vesuvius. Many of the
city's inhabitants were deluded by the initially light ash fall, believing
that they could survive by taking refuge from it. That misjudgment
caused at least two thousand people to be trapped and asphyxiated early
the following morning by the first of six hot, dust-laden clouds that
traveled down the mountain at speeds of more than a hundred miles an
hour. Those overcome by the heat and gases were buried shortly
thereafter by a flow of volcanic matter. Pompeii was ultimately
entombed under between nineteen and twenty-three feet of ash and
pumice, which left only the tops of the tallest buildings visible.

Herculaneum, located on the coast between two streams that flowed
down the slopes of Vesuvius, was spared the deluge of pumice and ash
during the early hours of the eruption, but on its second day the town
was buried by a series of hot, ash-laden clouds, or surges, alternating
with volcanic flows. It was long believed that most of the inhabitants

---

*Modern Ercolano enjoys a view of the Mediterranean from the slopes of Vesuvius
just as Herculaneum, its ancient predecessor, did. The surf line is barely discernible at
the bottom right of this photo. Today, as in antiquity, olives, grapes, and up to four
crops of vegetables per year thrive in rich soil fertilized by volcanic deposits.*

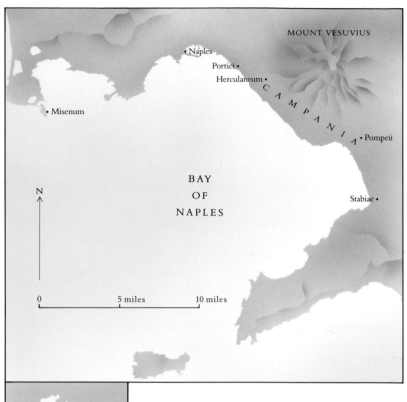

Bounded on the east by the spurs of the Apennines and on the west by the Mediterranean, Campania, the region around Naples, occupies a great volcanic plain. The length of Italy's western coast is broken here by the Bay of Naples, which is dominated by Mount Vesuvius.

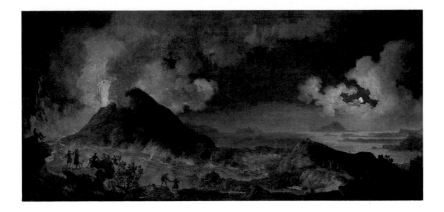

---

*The volcanic eruptions that periodically caused such devastation below Vesuvius continued in the eighteenth century. These dramatic occurrences provided subject matter for painters such as Pierre-Jacques Volaire, whose* Eruption of Mount Vesuvius in 1771 *(circa 1779; Art Institute of Chicago) is illustrated here.*

---

had had time to flee, but the recent discovery of more than a hundred skeletons at the base of the sea cliff suggests that many were caught by surprise and asphyxiated in boat houses on the beach, trapped between the deadly volcanic surges and the sea. Some buildings collapsed from the speed and force of these surges, while others were hermetically sealed by volcanic matter that seeped into them without disturbing the smallest or most fragile items. A later eruption buried Herculaneum and the Villa dei Papiri even deeper, between sixty and a hundred feet under an almost impenetrable rock-hard cover.

In A.D. 79 the Roman patrician and eminent natural historian Pliny the Elder was living at Misenum on the northwestern edge of the Bay of Naples, where he commanded the Roman fleet. Having observed a "black cloud" over the volcano on August 24, he set out to investigate it and, in his capacity as commander of the fleet, to rescue anyone in danger along the coast. He died in the attempt on the beach at Stabiae, most likely of asphyxiation. His nephew and adopted son, Pliny the Younger, who had remained behind at Misenum, wrote two detailed letters around A.D. 104 to the historian Tacitus, one describing his uncle's death and the other relating his own experiences during the eruption. Pliny the Younger's eyewitness account makes the horror of this catastrophe come alive after almost two thousand years:

> We encountered many weird and terrifying things. For instance, the
> vehicles which we had ordered, although they were standing in a

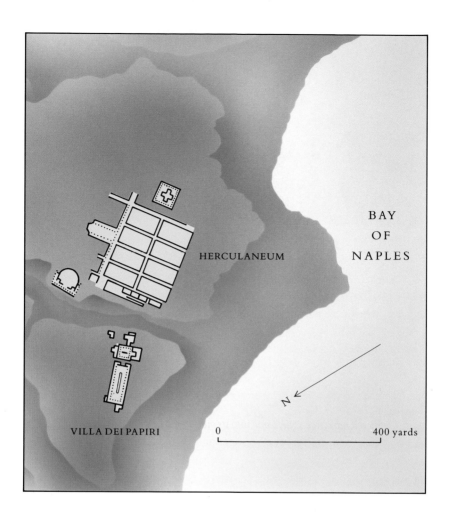

BAY
OF
NAPLES

HERCULANEUM

N

VILLA DEI PAPIRI

0                                    400 yards

---

*The map above shows the location of the Villa dei Papiri outside Herculaneum. Both were situated close to the edge of cliffs overlooking the Bay of Naples. Mount Vesuvius is off the map at the left.*

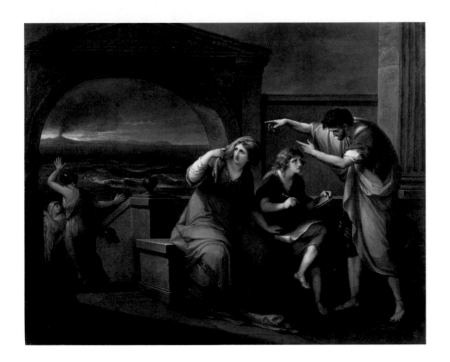

*History painting, which celebrated notable ancient and modern events in a precise, often mannered narrative style, came into its own in the late eighteenth century.* Angelica Kauffmann's Pliny the Younger and His Mother at Misenum, 79 A.D. *(1785; Art Museum, Princeton University), a typical history painting, closely follows the description Pliny left of his experiences during the eruption that buried Pompeii and Herculaneum.*

level field, were rushing in various directions, and not even with stones under their wheels would they remain in place. Then we watched as the sea was sucked back into itself, as though hurled back by the tremors of the land. Certainly the sea receded far enough to leave many marine animals stranded on the dry sands. From the other direction there rose a frightening black cloud broken by writhing, trembling, fiery spews; it gaped open from time to time to reveal vast flaming shapes. These were like bolts of lightning but were much larger.... The cloud descended to earth, covered the seas and covered the island of Capri and the outermost parts of the cape of Misenum.... Now ash was falling but still only lightly. When I looked back, a thick cloud was looming up behind and was following us like some torrent rushing over the land.... Night settled on us, not of the moonless or overcast sort, but one like a light suddenly gone out in a very small confined place. You could hear women shrieking, children screaming, and men shouting.... Both

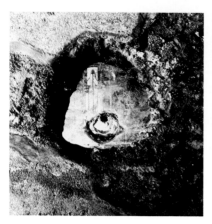

After the eruption of Vesuvius in
A.D. 79, looters—and perhaps even
some of the surviving inhabitants of the
buried towns—dug down into the
rubble to recover valuables. In Pompeii
searchers who reached the buried
buildings in many cases cut through
their walls to gain access to adjacent
rooms, making large holes like those
shown above in the House of the
Lovers. A small fragment of a wall
painting is barely visible in this
photograph, slightly above the center.
The systematic exploration of Pompeii
and Herculaneum that began in the
eighteenth century brought to light
three statues of women, one of which is
illustrated here. Today these statues
may be seen in the Staatliche
Skulpturensammlungen, Dresden.

the darkness and a great deal of heavy ash descended upon us once more. From time to time we had to stand up and shake the ash from ourselves, otherwise we would have been covered by it and crushed under its sheer weight.

Thousands of people were buried in the successive layers of volcanic matter.

When news of the eruption of Vesuvius reached Rome, the emperor Titus dispensed aid to the survivors out of his private funds. He also sent search teams to Pompeii to unearth what valuables they could, but the teams were recalled a year later to cope with the effects of a great fire in Rome. Robbers and looters then took over at Pompeii, gaining access to buried buildings by sinking wells down through the relatively loose layers of ash and small pieces of lava, called lapilli, thrown out by the volcano during the eruption. From these wells the looters could move horizontally from room to room in the buildings.

Herculaneum, buried much deeper than its neighbor city by solidified ash flows, largely escaped ancient treasure hunters, although a few salvage attempts apparently were made there. While the names of Pompeii and Herculaneum survived in ancient literature, and rumors of hidden treasure at the foot of the volcano persisted in local lore, the locations of the ancient cities near Mount Vesuvius gradually were forgotten.

The rediscovery of Herculaneum in the eighteenth century is a story of chance and treasure hunting. In 1711 a peasant, Giovanni Battista Nocerino, was deepening his well in the small fishing and farming village of Resina, the town that had been built on top of ancient Herculaneum (today the community is called Ercolano). Nocerino uncovered several fragments of colored marble which were then sold to Emanuel Moritz of Lorraine, prince d'Elboeuf. The prince, an officer in the Austrian army attached to the Neapolitan court, was building a luxurious villa for his Italian bride at nearby Portici and arranged further digging at Resina in the hope of finding more building material.

For several years d'Elboeuf underwrote excavations that were carried out by means of subterranean tunneling. The colored marble wall facings, columns, and sculptural fragments that were brought to the surface were used in the construction of the prince's villa. When complete statues began to emerge, however, the project took a new direction: the recovery of works of art. Three life-size marble statues of women were the most significant finds. Bypassing an antiquities law forbidding such exports, the prince smuggled the three statues out of Italy and presented them to his commander-in-chief, the Austrian general Prince François-Eugène de Savoie-Carignan.

When Prince Eugène died in 1736, the three statues entered the Dresden collection of Frederick Augustus, Elector of Saxony, who owned some of the finest classical sculpture outside Italy. His daughter, Princess Maria Amalia Christina, thus knew the statues from Herculaneum well, and

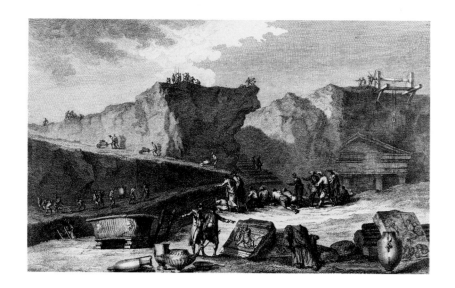

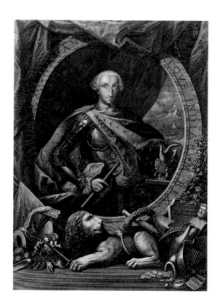

*The Abbé de Saint-Non's* Voyage pittoresque *includes the view of the excavations at Herculaneum shown above. Described in its eighteenth-century caption as "a complete invention," the engraving misrepresents the manner in which the work was carried out: rather than laying the city open to the sky, workers used underground tunnels. The excavations were carried out under the patronage of Charles III, who established a museum at his palace in Portici to house the sculpture, wall paintings, and other objects from the buried cities. His portrait illustrated here was used as the frontispiece for the official multivolume publication of the finds,* Le antichità di Ercolano esposte.

when she came to Naples as the bride of Charles III, the Spanish Bourbon king, she encouraged her husband to resume the work d'Elboeuf had abandoned some twenty years earlier. Charles was tantalized by the prospect of ancient treasures that could make his court the richest in Europe, and in October 1738 digging was begun again. The king appointed Roque Joaquin de Alcubierre, an engineer who had come to Italy with the Spanish army, to direct the project. In December of that year a Latin tablet was excavated that identified the site beneath Resina: *Lucius Annius Mammianus Rufus has financed the construction of this building, the theater of Herculaneum.*

As enthusiastic at the prospect of spectacular finds as his royal employer, Alcubierre widened Nocerino's original well shaft and dug tunnels in all directions from it. Bronze and marble sculptures wrested from the rock-hard ground were brought to the nearby royal palace at Portici, where a museum was established for them. Few records were kept of individual discoveries, and only undamaged finds considered to have artistic merit were kept. Many imperfect marble or metal objects were discarded or melted down for reuse. In his haste to enrich the king's museum, Alcubierre is reported to have ripped bronze letters from walls without first recording the inscriptions of which they were a part. Charles III considered Herculaneum and Pompeii to be his private property—he was, after all, paying for the excavations—and he jealously limited access to the museum at Portici. But requests for news about the discoveries from the two ancient cities increased, and so in 1755 he established the Accademia Ercolanense to study and publish information about the finds at both sites. The academy was doomed from the start by jealousy and intrigues among its members, and accomplished very little. It was a beginning, however, for engravings of the most important wall paintings discovered during the excavations were published by the royal press in 1757 in the first of eight volumes entitled *Le antichità di Ercolano esposte.* Only a hundred copies of this first volume, intended strictly for distribution by the king, were printed, but pirated editions in English, German, and French soon were circulated, thus making Herculanean and Pompeiian motifs accessible to a wider audience.

In the mid-eighteenth century such publications were eagerly sought after, for the discovery of Herculaneum and Pompeii inspired a new appreciation for classical styles and had a profound impact on the cultural life of Europe. The fascination with antiquity that had originated in the Renaissance and received new impetus during the Enlightenment was the catalyst for the development of Neoclassicism, which spread across Europe with remarkable speed. The artists, writers, and composers of this period revered antiquity as a time of perfection in art and design. Antique models inspired changes in the eighteenth-century decorative arts, painting, architecture, dress, and jewelry. For example, the Englishman Josiah Wedgwood used decorative motifs from antiquity on the ceramics pro-

duced by his factory, and in France the Sèvres manufactory reproduced "Pompeiian" wall paintings on its porcelain. Decoration *à la grecque* came into vogue in Paris, where the ornate curves of the Rococo period were replaced by rectilinear forms and classical symmetry. The popularity of the Neoclassical style in America is evidenced, for example, by Thomas Jefferson's decision to design Monticello as a classical revival building.

A visit to Italy, its excavations, and—if possible—the royal museum at Portici became a must for every serious student, artist, and tourist. Already in 1749 Madame de Pompadour, mistress of King Louis XV, had organized a tour to Italy for her brother in order to further his artistic education. In the entourage was the artist Charles-Nicolas Cochin. Although he visited the Portici museum, Cochin was not allowed to make any drawings while there. However, his illustrations from memory of the finds he had seen were reproduced in a small book, *Observations sur les antiquités d'Herculanum,* which, when published in 1751, gave the French their first glimpse of the treasures.

In 1758 another important visitor came to the royal museum: the German art historian Johann Joachim Winckelmann. Annoyed by the restrictions precluding sketching and note-taking there, Winckelmann wrote a highly critical letter about the museum to his German patron. Although his comments earned him the wrath of the Neapolitan court, his observations about antiquity made on this and three subsequent visits helped to inspire the Neoclassical movement and to earn him a firm place in the history of art. Winckelmann was the first to classify the archaeological finds and to distinguish between Greek art and Roman copies. By applying the methods of historical research to ancient art, he laid the foundation for modern art history. As an alternative to the aimless amassing of ancient objects, Winckelmann proposed that such objects be studied as expressions of Greek and Roman culture and customs. In the process he opened up antiquity for the eighteenth century. The German poet Johann Wolfgang von Goethe wrote of

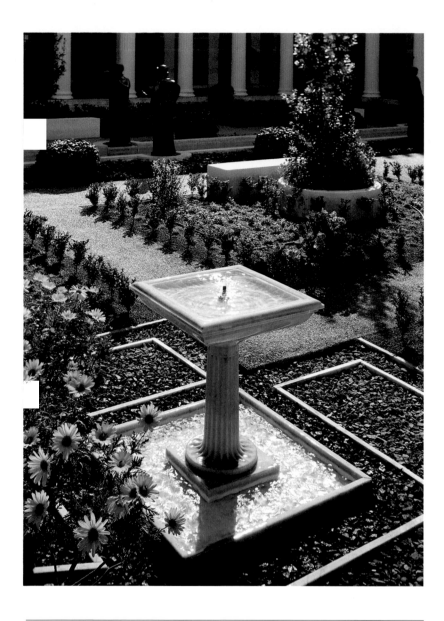

The function of the clock (circa 1785) illustrated above at the far left was practically obliterated as its designer fashioned a sculptural group showing two devotees making offerings at the altar of Vesta, Roman goddess of the hearth. Since the clock was part of a mantelpiece ensemble, the association with fire was appropriate. The influence of recently discovered objects from antiquity can be seen in details such as the griffins at the bottom holding scrolls recalling those in the ceiling of the Museum's Basilica. Publications with engravings like the one shown above at the near left, by Charles-Nicolas Cochin, disseminated information about new finds. Descriptions in the excavation reports of four fountains with similar basins formed the basis for the re-creations in the Museum's Inner Peristyle Garden, shown here.

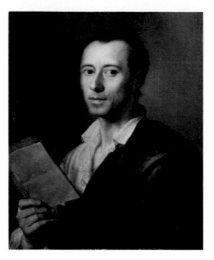
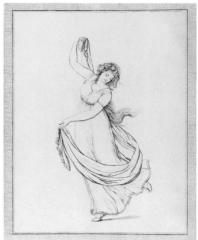

*Johann Joachim Winckelmann, shown here in a contemporary likeness by the noted
portraitist Anton Raphael Mengs (New York, Metropolitan Museum of Art),
visited the royal museum at Portici on four separate journeys. Winckelmann's
enthusiasm for the antique, which was shared by many contemporary scholars, also
inspired changes in popular taste, including women's fashion. A noted personality of
the time, Lady Hamilton, who lived in Naples with her husband, the British
ambassador there, sometimes entertained guests by striking poses inspired by
paintings on Greco-Italian vases in his famous collection. Lady Hamilton, who is
immortalized in numerous portraits wearing costumes evoking antique or Near
Eastern fashions, is represented here in an illustration from* Lady Hamilton's
Attitudes, *a 1794 collection of engravings.*

Winckelmann that he was "like Columbus who had in his mind a notion
of the New World before he actually saw it."

Goethe himself was among the many travelers who flocked to Naples
at the end of the eighteenth century to admire the relics of the ancient past.
Of the museum at Portici he remarked, "That museum...is the alpha and
omega of all collections of antiquity; there you see right clearly how far
ahead of us the ancient world was in a joyous sense of art, if in skill in
handicrafts in the strict sense it was much behind us." The finds that
emerged from the glorious past of Campania did not always measure up to
that evaluation, however. The erotic art that was found was considered so
shocking that it was hidden in a "secret" room in the royal museum. The
seeming lack of artistic merit of many of the finds, particularly the wall
paintings, also aroused puzzled curiosity. In fact this "lack" was often due
to their less-than-perfect state of preservation.

Although excavation work continued at Herculaneum under the

direction of Roque Joaquin de Alcubierre, after 1748 he focused most of his attention on newly discovered Pompeii, where the king had also given him permission to dig. By 1750 Alcubierre's obligations as a lieutenant colonel required him to move to Naples, however, and he requested that someone else be appointed to oversee the work at Herculaneum under his supervision. Shortly before the arrival of this new overseer—Karl Weber, a Swiss engineer who had worked for Charles III since 1735—well diggers working in a garden near the Herculaneum excavations struck some ancient marble. Further digging revealed an elaborate circular marble floor, which was lifted out piece by piece and reassembled at Portici. That floor, a copy of which is incorporated into the Getty Museum in the so-called Temple of Herakles, marked the discovery of the Villa dei Papiri.

Throughout his years of work at Herculaneum, Weber filed weekly progress reports to Alcubierre. These reports seem to indicate that the relationship was strained by the conflict between Weber's systematic method of excavation and Alcubierre's less careful approach. Despite the latter's repeated exhortations to get on with the search for art objects, Weber took the time to make several drawings of the subterranean excavations, notably a detailed floor plan, dated 1754, of the Villa dei Papiri. This plan, which included notes describing and locating specific objects discovered at the site, was later revised either by Weber himself or by his successor, Francesco La Vega. Without Weber's original rendering, however, there would be no systematic (if partial) record of the ground plan of one of the grandest of ancient Roman villas and one of the greatest archaeological discoveries of the eighteenth century.

The plan of the Villa dei Papiri as revealed by Weber shows the building to have conformed to the atrium house type that was common in Campania in the centuries before A.D. 79. Although the villa was not fully explored in the eighteenth century (nor has it been since then), many other buildings buried along with it have been. From them a great deal has been learned about the houses of patricians and plebeians during this period.

Many people in Pompeii and Herculaneum lived in residential blocks with shops or taverns at street level and living quarters above. By the third century B.C., however, some wealthier citizens lived in single-family dwellings, each of which was built around a central hall called an atrium. The basic floor plan of the atrium house stressed symmetry and axiality. The entrance from the street led through a hallway to the atrium, along the sides of which were small cubicles used originally as bedrooms. An opening in the atrium roof, known as a compluvium, normally admitted light as well as rainwater, which was stored in a basin or pool—the impluvium—set into the floor under the opening. Occasionally, such openings had grilles for reasons of security. The atrium was the public part of the house where business was conducted and visitors were received.

During the period of the Roman Republic, atrium houses became more lavish and varied in appearance. The old-fashioned walled gardens behind

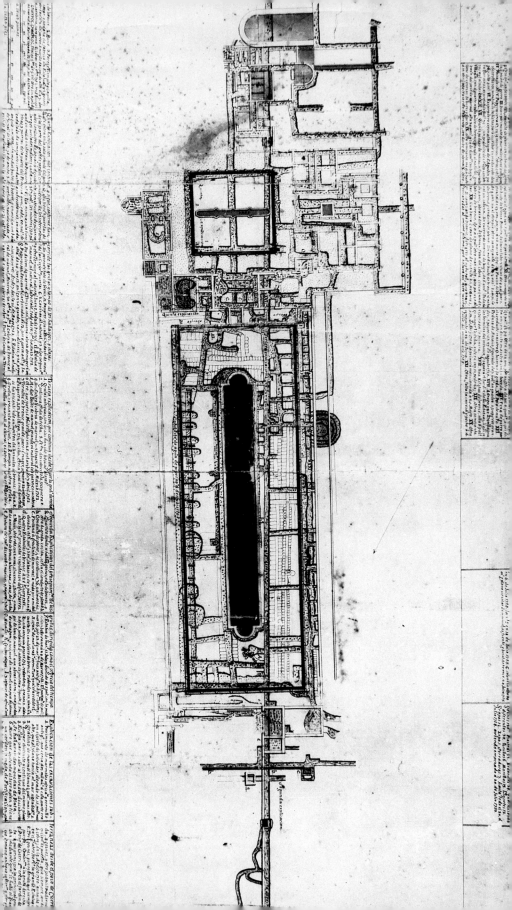

them were replaced by Greek peristyles, interior garden courts surrounded by colonnades. The private rooms, including the dining room, bedrooms, and baths, now surrounded the peristyle, and the traditional, somewhat gloomy atrium, once the center of the home, gradually became a mere entrance hall.

The typical atrium house was oriented toward the interior and had few windows facing the street. All the rooms opened onto the atrium or peristyle garden, deriving indirect light from them—an advantageous use of light and shade in hot climates. Seaside villas appear to have been an exception; contemporary Roman frescoes show them to have had colonnades and porticoes facing the sea, probably to take advantage of the views and cooling sea breezes.

The Villa dei Papiri, then, was a *villa suburbana,* essentially an urban atrium house transferred to the countryside as a retreat for city dwellers. The word *villa* originally referred to a rural dwelling run for agricultural profit by slave labor. Though an estate like the Villa dei Papiri may have had a small working section, such as a wine press, houses of this type, as we have seen, were more important to Roman patricians as places of escape from the political and social tumult and demands of life in the capital. In his letters Cicero, for instance, mentions seeking solace at his villas (including one at Pompeii). Pliny the Younger wrote long, loving descriptions of the charm and beauty of his seaside villa in Laurentum, seventeen miles from Rome near the mouth of the Tiber, and of his villa in the Tuscan mountains, places where he could read and write in peaceful surroundings and entertain friends. These villas incorporated many features of the atrium house but on a grander and more elegant scale, and they often included several gardens like those found at the Villa dei Papiri.

The plan of the Villa dei Papiri evolved over almost three centuries. The original layout, with an atrium and rooms arranged around an intimate peristyle garden, probably dated to the early second century B.C. But as a close scrutiny of Weber's plan shows, extensive changes, probably made in the first century B.C., expanded the original structure to create an extraordinary villa. A second peristyle, 310 feet long and 104 feet wide, was added, with a portico on the seaward side consisting of 65 columns. In the center of this peristyle was a pool 218 feet long and almost 24 feet wide, as large as some of the imperial public baths later built in Rome. Such a large pool would have required a steady supply of water, and indeed Weber reported finding a complex hydraulic system in the villa that fed its

---

*Karl Weber's plan of the Villa dei Papiri provided the basis for the layout of the Getty Museum. The plan, the greater part of which is illustrated here, includes the walls of the building, the pools, and the excavation tunnels. Its orientation and long, narrow pool were adopted in the Museum's plan.*

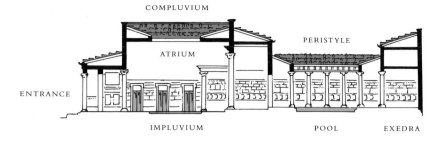

COMPLUVIUM

PERISTYLE

ATRIUM

ENTRANCE

IMPLUVIUM    POOL    EXEDRA

pools, fountains, and baths with water from Herculaneum's aqueduct.

Karl Weber mined the Villa dei Papiri from 1750 to 1765. Three and sometimes as many as six tunnels were worked on simultaneously by half a dozen men, some of whom were slaves or convicts doing forced labor. From these explorations came an amazing trove of sculpture: small, medium, and large bronzes and marbles, including several busts. Most of the latter represented famous Greek military and civil leaders, philosophers, poets, and literary figures. Lifelike sculptures of animals, demigods, putti with dolphins, and satyrs surrounded the villa's large pool and the impluvium in the atrium. These statues, which are remarkably well preserved—a testimony to Weber's insistence on the careful chipping away of volcanic matter—are displayed today in the Museo Nazionale, Naples. The gardens of the Getty Museum contain modern replicas of many of them.

Of great interest to its eighteenth-century discoverers was the library of papyrus scrolls found in 1754 which gave the villa its modern name. In a small room, more than two thousand badly burned rolls were neatly stacked on shelves and heaped on a central book stand. The first attempts to unroll a few of the scrolls destroyed them, so Father Antonio Piaggio, who had worked with manuscripts in the Vatican library, was brought to Naples in 1755 to try to unroll the papyri and study them. The work was excruciatingly slow; after four years of experimentation, he had unwound only three of the fragile documents. The first turned out to be a treatise on music by the first-century-B.C. philosopher Philodemus of Gadara, a town near the Sea of Galilee. Fifty years later, only about a hundred of the scrolls had been deciphered, and today little more than half have been read. The fact that most of the texts are by Philodemus has been a disappointment to classical scholars, who hoped that the texts would include long-lost works by the great Greek and Roman poets, dramatists, philosophers, and historians. The great majority of the scrolls' texts are in Greek, which suggests that a Latin library is still buried in an unexcavated part of the Villa dei Papiri, since Roman owners of Greek and Latin libraries commonly kept the two separate.

The large number of scrolls by Philodemus found in the library of the

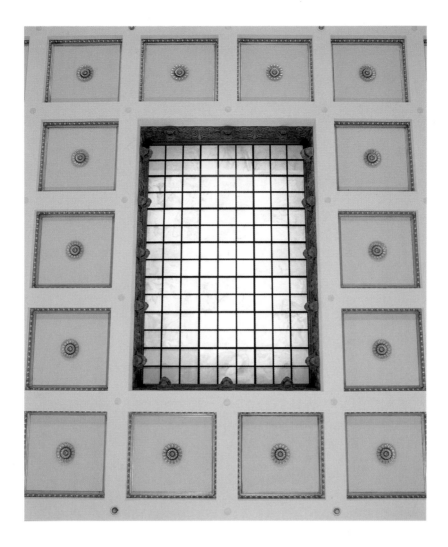

The basic structural elements of a typical Roman atrium house can be seen in the section drawing illustrated on the opposite page. While in most ancient houses the compluvium, or opening over the water basin, was intended to allow rainwater to collect below, the Museum's compluvium, framed by rows of sculpted lions' heads, is closed. The centralized gilded rosettes in the ceiling are surrounded by borders of egg-and-dart ornament, a popular motif in antique art.

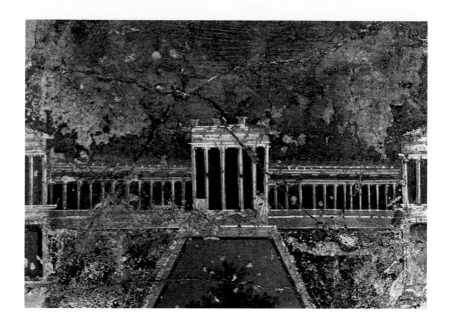

Ancient frescoes like this one provide evidence for the appearance of the lavish seaside villas favored by the Roman aristocracy. While the Villa dei Papiri's large peristyle garden may have been surrounded by solid walls, there seem to have been similar exterior porticoes along the side facing the sea.

Villa dei Papiri may link it to the wealthy, prominent Roman consul Lucius Calpurnius Piso, Philodemus' patron (and, as we have seen, a protagonist in J. Paul Getty's *A Journey from Corinth*). Cicero wrote about the close relationship between these two men, and in a surviving poem Philodemus actually addresses his patron and describes himself as Piso's friend. It may have been Piso's son, L. Calpurnius Piso Pontifex, who was responsible for the expansion of the Villa dei Papiri at the end of the first century B.C. We know nothing, however, about the villa's owner at the time of Vesuvius' cataclysmic eruption in A.D. 79. Certain features, including a large amount of grain stored in some of the rooms, suggest that the building may have been undergoing a transformation from deluxe country house to agricultural villa when the volcano exploded. The presence of several lime tubs further implies that the building may have been under repair, perhaps as the result of damage from the earthquake in A.D. 63.

By 1761 exploration work at the Villa dei Papiri had virtually stopped. The inhabitants of Resina regularly complained that their houses were developing cracks or even collapsing into excavation tunnels that had weakened the ground. Support columns in the tunnels partly alleviated this problem, but there were not enough of them. Furthermore the

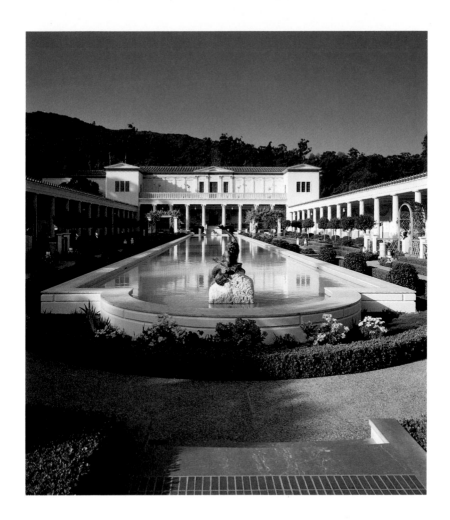

This view of the Museum looking north along the primary axis of the Main Peristyle Garden conveys an accurate sense of sun-warmed, ordered calm. The similarity between Southern California's light and that of southern Italy lends an additional note of authenticity to the architectural ensemble.

*Greek texts are still legible on partially carbonized scrolls found in the Villa dei Papiri. Recently, archaeological work resumed there under the auspices of the Italian government; excavators consider the buried library to be the villa's greatest potential treasure.*

seepage of water and poisonous gases from the volcanic rock made underground work dangerous. In 1765 the access wells were sealed.

As the flow of spectacular finds dwindled and excavation problems increased, work at other sites in Herculaneum was abandoned, too. In 1828 excavations were taken up that lasted a few years, and, for the first time, complete removal of the thick, rock-hard volcanic deposits was attempted. But the work was difficult, and only two of the ancient city blocks were exposed. In 1869, under the auspices of the Italian king Victor Emmanuel II, two more blocks were uncovered. Work was discontinued, however, when the excavators approached the houses of modern Ercolano, and local landowners once again objected. In 1927 the landowners received compensation from Mussolini, who supported new archaeological explorations. Today digging continues, facilitated by the use of compressed-air drills and the presence of conservation experts. Government-sponsored excavations begun in 1987 at the Villa dei Papiri seek to unearth further remains of its great library. As much as half of the city remains buried, however, waiting—like the Villa dei Papiri—to yield its secrets.

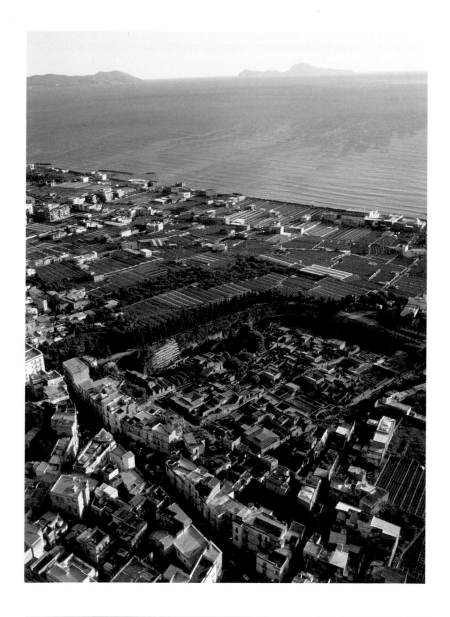

*In a reversal of the usual pattern of human habitation, in which more recent settlements take over and obliterate older ones, modern Ercolano has gradually given way to its ancient precursor, visible at the center of this photograph.*

How closely the Getty Museum follows the plan of the Villa dei Papiri can be judged from this isometric drawing of a reconstruction of the villa superimposed on Weber's plan. Besides the long outdoor pool, other important features include the liberal use of colonnades surrounding enclosed areas and looking outward toward the coast, and a main structure surrounding an atrium. Also of interest is the manner in which the Museum is situated in a suburban area of private residences similar to that which surrounded the Villa dei Papiri.

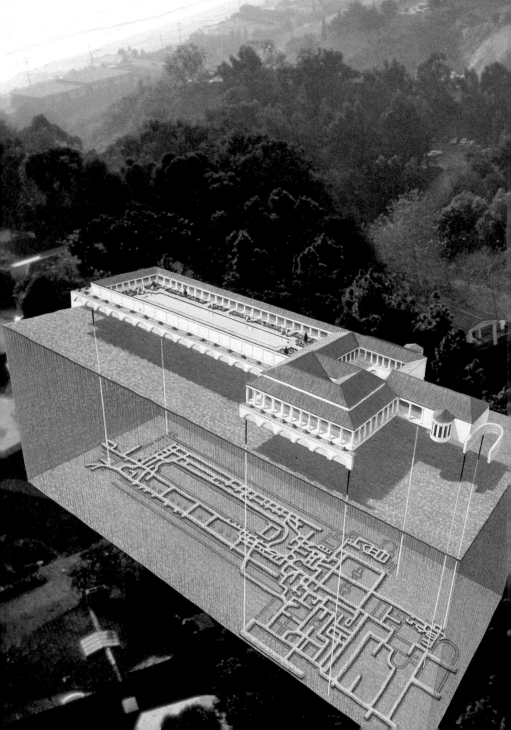

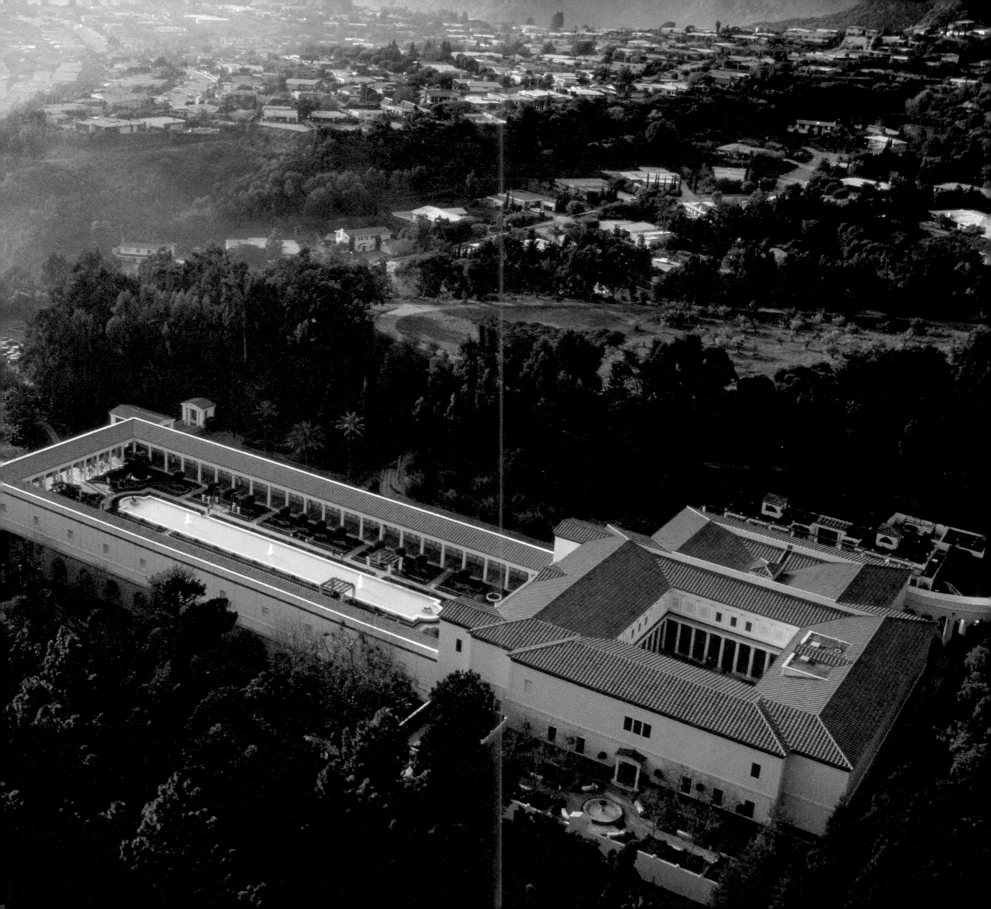

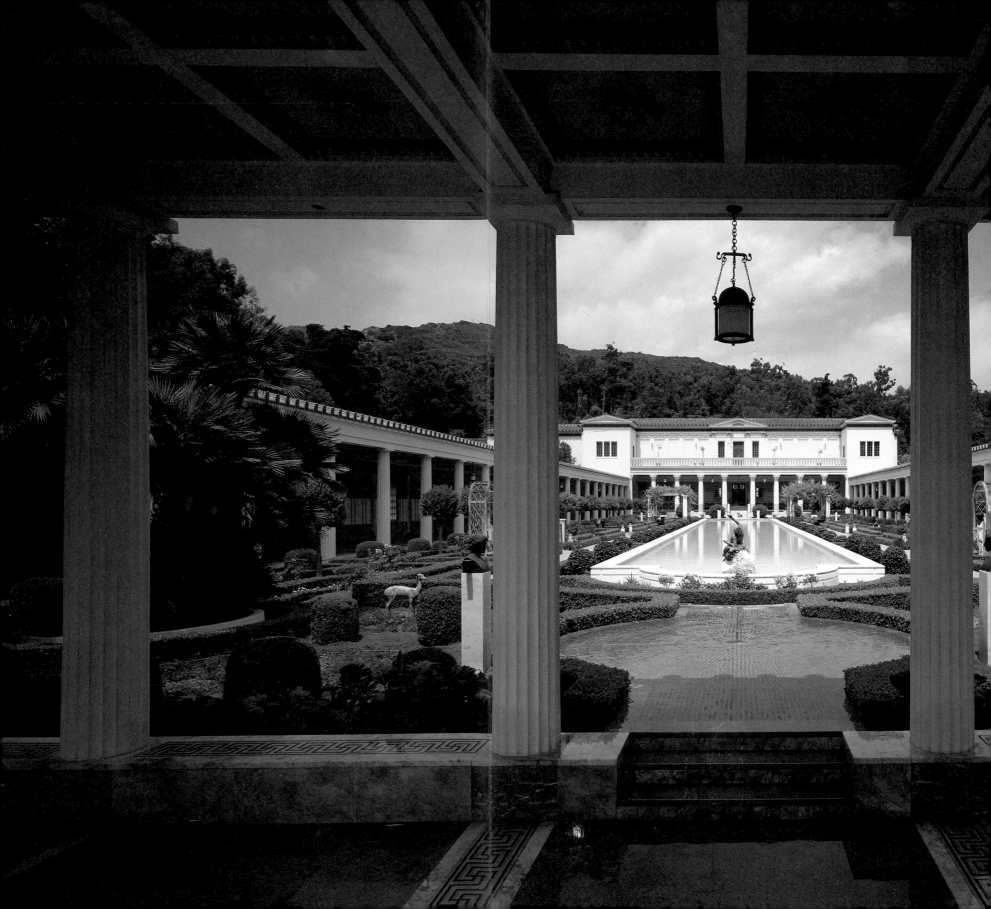

# A WALK THROUGH THE
# MUSEUM AND ITS GARDENS

As we have seen, the size and exterior design of the J. Paul Getty
Museum follow Karl Weber's plan closely. Because the plan is incom-
plete, however, many details of floors, walls, ceilings, and decor in the
Museum are based on information gleaned from Campanian and Roman
villas and houses other than the Villa dei Papiri. These details evoke the
kind of secluded, private environment in which the patrician owner of a
Roman villa would have displayed and enjoyed his possessions. Some
features of the Museum's design were dictated by the needs of a modern
exhibition space. For example, a full second story was built around the
Inner Peristyle to house the collections of paintings and decorative arts.
Selected illuminated manuscripts, drawings, photographs, and sculpture
acquired since 1981 are also on view here. Two-story buildings were
common in Herculaneum, and it is probable, though not absolutely
certain, that the Villa dei Papiri had upper rooms.

Basic construction of the Museum was completed by the summer
of 1973, and it opened to the public in January 1974. To re-create the
atmosphere of a Roman villa successfully, the landscaping of the grounds
had to be planned and executed as carefully as the building itself. Gardens
were an important component of a Campanian property; often house
and garden were so closely integrated that it was hard to tell where one
ended and the other began.

Excavations at Pompeii have shown that in the first century A.D. even
the most humble house had a garden, a small walled-in space in which to
grow herbs and greenery; shade might have been provided by one or two
fruit trees. Roman home-owners worked, played, ate, and relaxed in
their gardens, which were meant to catch cooling breezes and make the
most of pleasant vistas. The garden decorations of grander houses often

---

*Like all of the bronze lamps in the Museum, the one visible here between two Doric
columns in the South Porch is an adaptation of an original from Pompeii, where
such lanterns were carried at night. At the Villa dei Papiri, the entire length of the
main peristyle occupied a single level. Since the Museum's Main Peristyle sits on a
slope, adjustments had to be made to accommodate the angle of the site. Roman
architects made such adjustments by utilizing arched substructures. At the Museum
the same result was attained by constructing a parking garage with a sloping floor
beneath the Main Peristyle.*

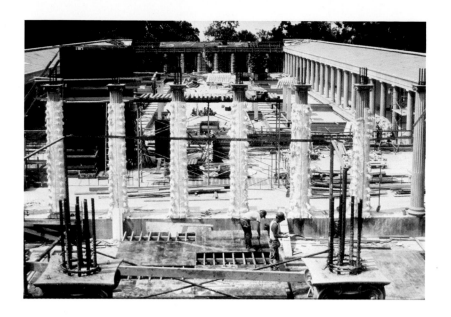

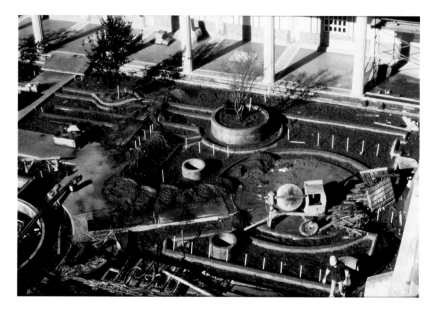

*The Main Peristyle Garden is seen here under construction. The view toward the ocean shows the Doric columns along one side already in place, and the incomplete Corinthian columns still encased in their molds. Each concrete column is reinforced with several steel rods to provide earthquake resistance. During the construction of the garden itself, wells four feet deep were left for trees whose roots could not survive in the two feet of soil used elsewhere to minimize the weight carried by the garage ceiling below. An elaborate system of pipes was set into the soil to allow for efficient, unobtrusive watering and fertilizing of trees and plants.*

*The Museum's access road is paved to resemble the lava blocks used in the streets of ancient Herculaneum. This view, which looks south toward the end of the Main Peristyle, gives an accurate impression of the Museum's verdant setting.*

included representations of woodland creatures—the god Pan, satyrs, and nymphs—in the form of sculptures and frescoes. Peristyles, fountains, and pools were also common in larger gardens.

The re-creation of a Roman garden in Malibu was a challenging but feasible undertaking due to the similarity in the climates of Southern California's coastline and the Bay of Naples. Although we do not know what specific plants grew in the gardens of the Villa dei Papiri, Roman literature and wall paintings from Pompeii and Herculaneum (together with scientific analyses of carbonized seeds, fruits, vegetables, nuts, and woods) provide general information about landscaping fashions and the plants the Romans used and enjoyed. For the Museum's plantings, many seeds and bulbs were imported from Italy and acclimatized in a local nursery. Evergreens were chosen to be predominant just as they were in Roman formal gardens; these include laurel, box, myrtle, ivy, and oleander. Although roses, lilies, violets, daisies, irises, and bellflowers were planted for seasonal color, the overall impression made by the Museum's gardens is one of lush but controlled greenness.

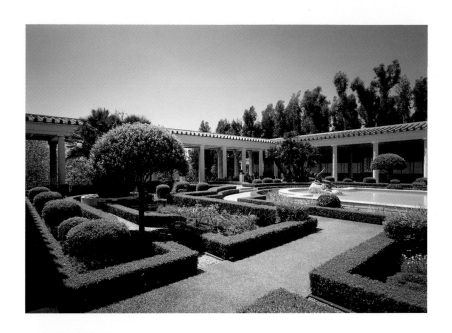

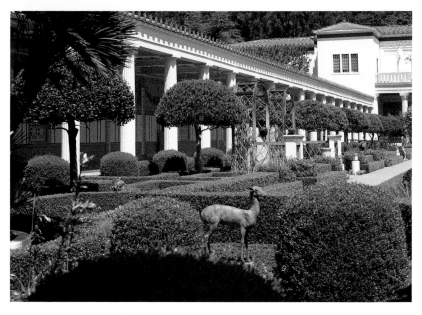

*The Main Peristyle Garden replicates that of the ancient villa in size and layout except for two details. The southern wall of the Museum's peristyle was left open to allow visitors a view of the ocean, and the pool was made considerably shallower than that of the ancient villa to obviate the need for a lifeguard. The delicate bronze statue of a deer, copied from one of several found in the Villa dei Papiri, introduces a wild woodland creature into this highly manicured setting, thus recalling a Roman horticultural ideal: to combine elements of nature and civilization in garden design.*

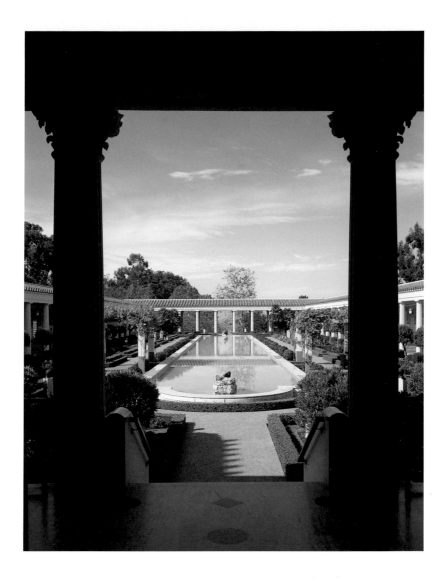

*Framed by Corinthian columns, this view of the Main Peristyle Garden, which looks back from the Museum proper along the pool toward the Pacific, recalls Roman murals of luxury villas like the one illustrated on page 30.*

# THE MAIN PERISTYLE GARDEN

The outer walls of the Main Peristyle Garden are finished in smooth, painted concrete, which visually approximates the stucco that would have covered the walls of the Villa dei Papiri. The inner walls of the Main Peristyle Garden are embellished with painted garlands of flowers and fruit and illusionistic frescoes depicting elaborate columns in front of plain or carved marble panels and niches. The excavation reports concerning the Villa dei Papiri mention numerous small paintings that were cut out of the walls and brought to the royal museum at Portici, but most were of poor quality. Thus the majority of the wall paintings in the Museum are based upon prototypes from other ancient houses.

The coffered ceilings of the Main Peristyle were suggested by the remains of the Villa of P. Fannius Synistor in Pompeii. (Many ancient Roman houses are referred to now by the names of their owners, characteristics of their decor, or objects discovered inside or near them.) The rose-colored terrazzo floors in the Main Peristyle, called *opus signinum* by the Romans, are of a type common in Roman houses. Pebble-sized pieces of marble, granite, and brick were set in concrete, ground down to a smooth surface, and polished. In the Main Peristyle floors, every other bay has a central geometric pattern in terrazzo based on mosaics preserved in Pompeii. Although Weber described marble and mosaic floors in the original villa, it is possible that some of the floors for which he used the term *mosaic* were in fact terrazzo.

The obvious focal point of the Main Peristyle Garden is its large pool framed by symmetrical landscaping. Around the pool and throughout this garden stand copies of bronze statues and busts which were cast in Naples from the Roman originals and placed approximately where Weber found them in the Villa dei Papiri. Trimmed hedges of box enclose mounded ivy, old roses, oleander bushes and trees, alyssum, violets, bellflowers, irises, and woolly yarrow. Two square arbors are covered with grapevines, and trellis bases are planted with acanthus, the plant whose leaves inspired endless decorative motifs in antiquity. Trimmed laurel, fan palm, and pomegranate trees further sustain the formal, peaceful atmosphere of this garden.

---

*While the interior walls shaded by the colonnades of the Main Peristyle are stuccoed and painted, the scored concrete surfaces of the outer, lower ones show how such walls looked before stuccoing. In fact many of the buildings preserved in Herculaneum and Pompeii have a similar appearance today since their stucco facings have fallen off. The reticulated brickwork and circular decorative motifs on the Museum's lower walls were copied from Pompeiian buildings, as were the semicircular grilles within the archways. While the original grillwork was solid, the Museum's was left open for ventilation as a concession to the automobile.*

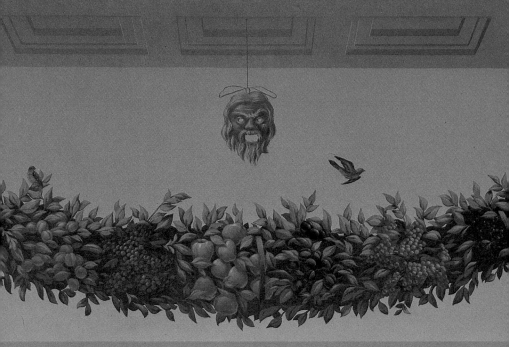

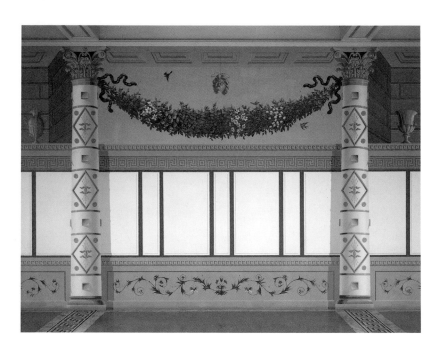

*Art historians have classified the wall paintings that survive from ancient Pompeii according to the styles in which they were executed. The so-called Second Style, developed during the period when the Villa dei Papiri's large peristyle was built, is replicated in the Museum on the long walls of the Main Peristyle.*

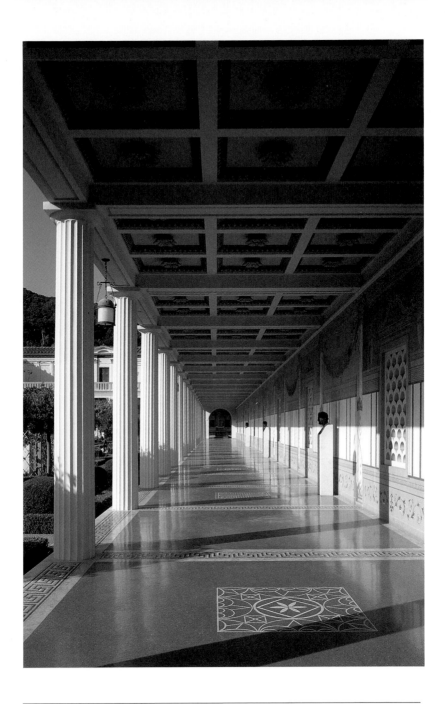

*This view along the colonnade at the eastern side of the Main Peristyle Garden shows the striking shadow patterns produced by the late afternoon sun. Copies of ancient busts have been set on tall bases at intervals along the wall between the simple rectangular grilles. The coffers here and in the Inner Peristyle were cast individually in plaster of paris before being set in place in the ceilings. They were then painted to harmonize with the adjoining walls.*

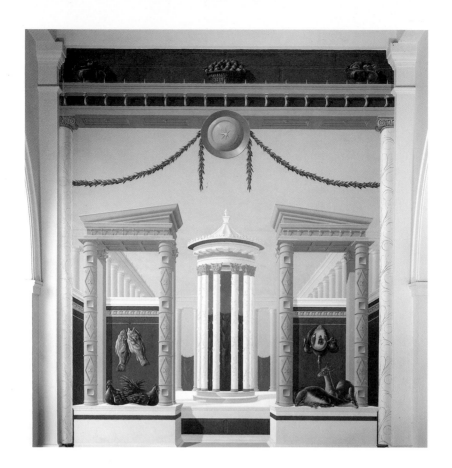

*Only one mural from the Villa dei Papiri, showing trussed-up ducks and deer, is reproduced in the Museum. It was found in the ancient villa's atrium; the copy may be seen at the northeast corner of the Museum's Main Peristyle. Discovered in the mid-eighteenth century, the mural, which now is housed in the Museo Nazionale in Naples, was first published in an engraving in 1862. The deer motif, a popular one in Campanian murals, was used frequently to decorate dining areas, since in Roman cuisine venison was considered a special delicacy.*

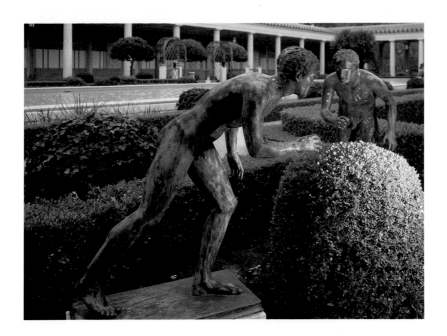

*Cast in Italy piece by piece in molds taken from the originals they replicate, the bronze statues that populate the Museum's gardens—including these of two young athletes, tentatively identified as runners or wrestlers, in the Main Peristyle Garden—are, as we have seen, all copies of works discovered at the Villa dei Papiri. The darkened surfaces of the copies resemble the patina the originals now have as a result of eighteenth-century efforts to conserve them by passing them through fire.*

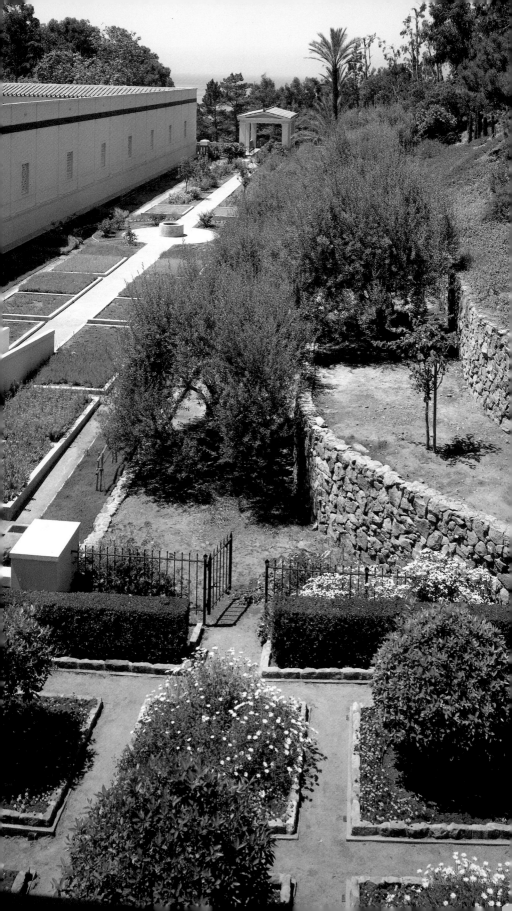

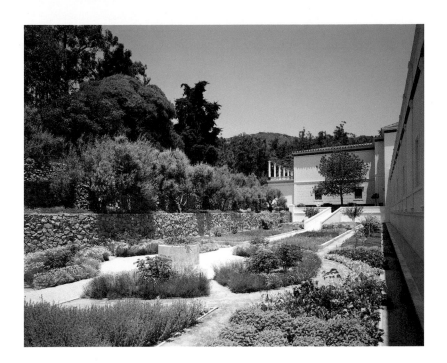

## HERB GARDEN

Although Weber's plan gives no indication of windows or grilles in the main peristyle walls of the Villa dei Papiri, simple openwork screens are set into the Museum's garden enclosure along the east and west. Those on the west side give a view of the Herb Garden just below. The latter is a re-creation of a Roman kitchen garden, an important feature of Roman homes. In geometrically arranged beds grow some fifty different kinds of herbs, all of which were used in Roman times for culinary, medicinal, religious, or decorative purposes. The plants include mint, dill, coriander, oregano, marjoram, chamomile, and several kinds of thyme. Garlic, fennel, and peas and other vegetables are planted among them. Fruit trees—apple, peach, pear, fig, and citrus—and grapevines abound, and a typically Mediterranean olive grove stands on the terraces above the garden.

---

*The Herb Garden, located to the west of the Main Peristyle Garden, runs the latter's entire length. In its neat, axially arranged raised beds grow many of the same plants and trees that filled Roman kitchen gardens and arbors. As is typical of herbal plantings, the color scheme is restrained, with a range of greens, gray-greens, and blue-greens set off by occasional sweeps of yellow, blue, or lavender flowers and a few brightly colored blooms. The changing effects of light on the yellow-brown retaining walls of native rock, the trim gravel paths, and the severe exterior walls of the Museum are visible here.*

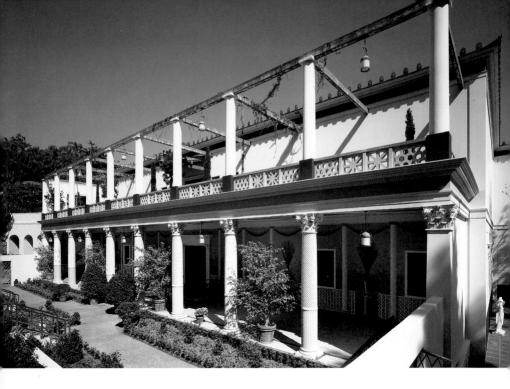

## EAST AND WEST GARDENS

East and west of the Museum's main building are two other gardens. The West Garden, in which the Tea Room is located, is laid out symmetrically in terraces flanking two fountains that duplicate ones found at Pompeii and Herculaneum. Five small bronzes placed around the lower pool reproduce statuettes found by Weber in the atrium of the Villa dei Papiri. Tall columns with twisted fluting, copied from the Villa of San Marco at Stabiae, line the West Porch, whose illusionistic wall and ceiling paintings of trees, columns, latticework fences, fountains, and birds appear to extend and enlarge the garden itself.

The walled East Garden is dominated by two fountains. The first consists of a circular basin in the garden's center decorated with bronze tiger-head water spouts copied from spouts discovered in the ancient villa's atrium. The second is a colorful mosaic and shell niche fountain copied from one in the House of the Large Fountain in Pompeii. Shaded by sycamore trees, this small garden is private and quiet.

The gardens surrounding the Museum accurately reflect the varied interests of the owners of Roman villas, who successfully combined careful horticultural planning with selected architectural features and appropriate elements of religious and mythological imagery. The ordered serenity of the gardens serves as a fitting introduction to the Museum's interior spaces, which evoke a feeling of luxurious calm.

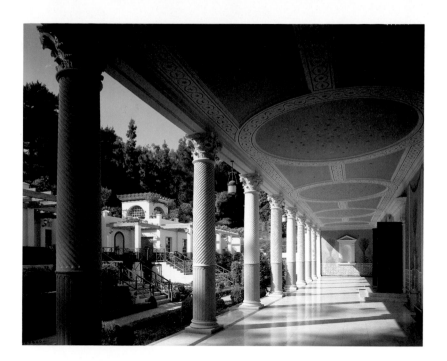

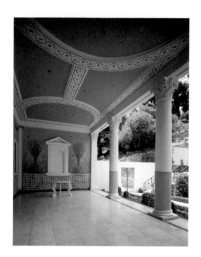

The Museum's West Porch, situated to the north of the Herb Garden, provides a haven from summer sun or winter rain. The colonnade, which faces the Tea Room (the latter is visible at the left in the photo above), re-creates the colonnade on the south side of the main building at the Villa dei Papiri, which may have marked the villa's entrance. Potted trees complement low plantings of box, ivy, and acanthus. The ceiling of the West Porch, visible above and at the left, features small painted birds and individual flowers. On either end wall is a white plaster blind niche framed by simple pilasters and a pediment, with paintings of palm trees at each side and simulated latticework fences below.

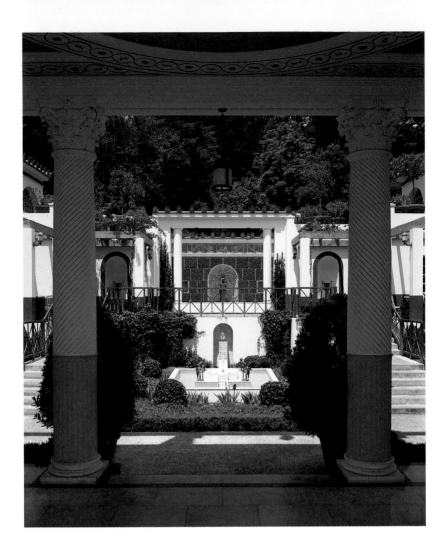

*False stonework and a bright blue mosaic frieze above a wall fountain, or nymphaeum, in the West Garden reconstruct similar features found in the House of the Skeleton at Herculaneum. The design of this fountain ensemble, seen here framed between two of the twisted columns in the West Porch, was based on an ancient prototype. The West Garden occupies one end of the Museum's east-west axis, at the center of which is the pool in the Inner Peristyle Garden, and at the other end of which are the two fountains in the intimate East Garden.*

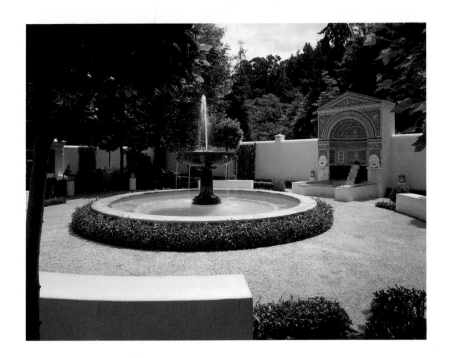

*Sycamore trees provide shade in parts of the enclosed East Garden, whose bright mosaic fountain flanked by masks of Tragedy and Comedy contrasts with the sedate circular fountain in the middle. As elsewhere in the Museum's gardens, the water in the mosaic grotto cascades down marble-faced steps into a small pool, while animal-head spigots spew forth streams of water in the East Garden's circular fountain.*

## MAIN VESTIBULE

Adapted as the main public entrance to the Museum, this space was actually the *triclinium*, or dining room, of the Villa dei Papiri. As in the villa, it is located between the Main Peristyle and Inner Peristyle gardens, and is separated from the former by massive bronze doors and from the latter by two fluted Corinthian columns of white marble. Marble columns were an integral feature of the Roman architectural vocabulary, but until the second century A.D. they were used almost exclusively for public buildings and temples rather than private houses. The columns between the Vestibule and the Inner Peristyle are meant to complement the marble used in the entrance space, but they are actually more elaborate than any such supports that would have been found in a private house prior to the second century.

The floor and walls of the Vestibule are inlaid with colored marbles in designs copied from various buildings in Herculaneum. Incorporating four types of marble—wine-colored porphyry from Egypt, dark green porphyry from Sparta, white *pavonazzetto* from Phrygia in present-day Turkey, and yellowish pink *giallo antico* from Tunisia—the floor copies one found in the House of the Deer in Herculaneum. The ceiling in the Vestibule has recessed, arched panels in a design similar to those in several houses in Herculaneum; its illusionistic vine motif incorporating putti, birds, flowers, fruit, musical instruments, and other motifs was taken from the House of the Orchard in Pompeii. The marble table in the center of the Vestibule is a modern copy of a table from a house in the same city.

## INNER PERISTYLE GARDEN

The square Inner Peristyle Garden, decorated in the style that was in fashion when the same part of the Villa dei Papiri was built, is much smaller and more intimate than the Main Peristyle Garden. Its walls have plaster-relief decorations consisting of multicolored false ashlars, or stone blocks, and pilasters. Thirty-six Ionic columns surround dark green plantings, mainly of box and ivy, and the garden's long, narrow pool. On curved marble offsets along the pool's sides stand replicas of bronze statues of women. Although the originals after which these copies were made were found in the large peristyle garden of the Villa

---

*Demonstrating some of the uses to which the Romans put the numerous varieties of marble at their disposal, the Museum's Main Vestibule, or lobby, employs many different types for flooring and wall coverings. The geometric patterns on the walls contrast with the relaxed floral ornament painted in the ceiling bays and were inspired by patterns in several different ancient houses. Through the open door at the left it is possible to glimpse the Main Peristyle Garden.*

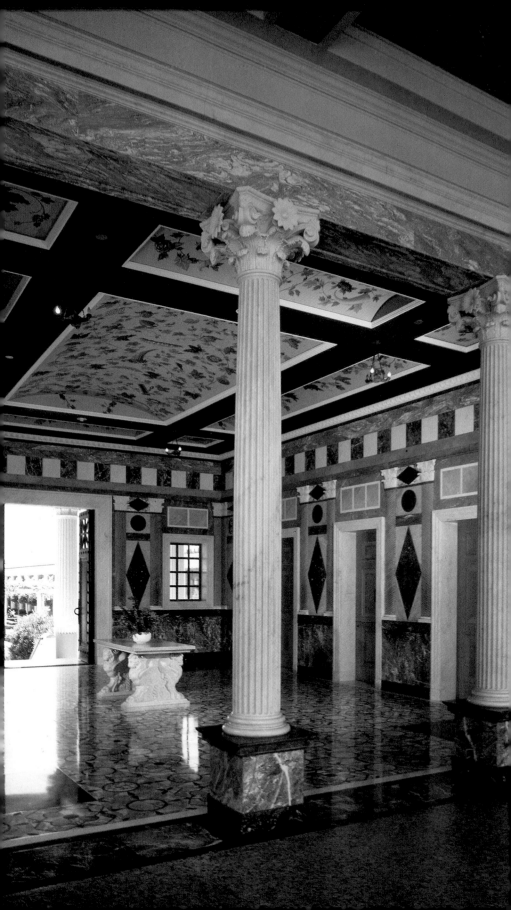

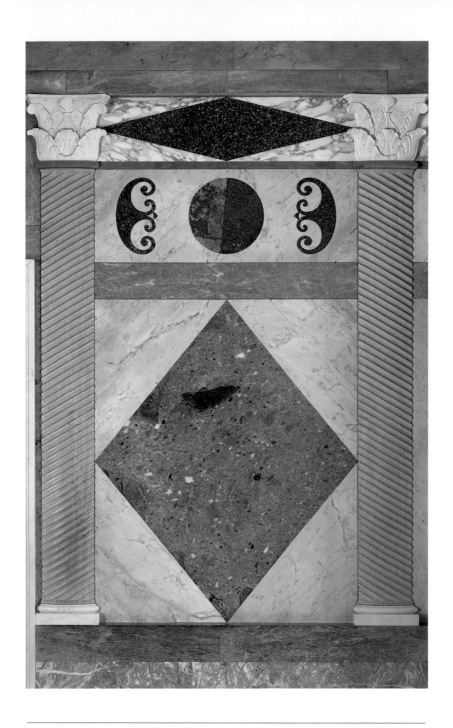

*The pilasters with twisted fluting that decorate the walls of the Main Vestibule were modeled on similar features in the House of the Relief of Telephos in Herculaneum.*

Examples of the three orders of classical architecture are to be found in the Museum. The ornate acanthus leaves and flowerets of the Corinthian order, the latest and most complex of the three, can be seen at the southern end of the Main Peristyle and also at the northern end, where the peristyle joins with the facade of the Museum proper. Ionic capitals, with their characteristic corner volutes and bands of egg-and-dart molding around the curved sides, can be seen in the Inner Peristyle. Their colored decoration was copied from the House of the Colored Capitals in Pompeii. Both Ionic and Corinthian capitals sit atop fluted columns. Simple Doric capitals, pillowlike in appearance, may be seen on the long sides of the Main Peristyle.

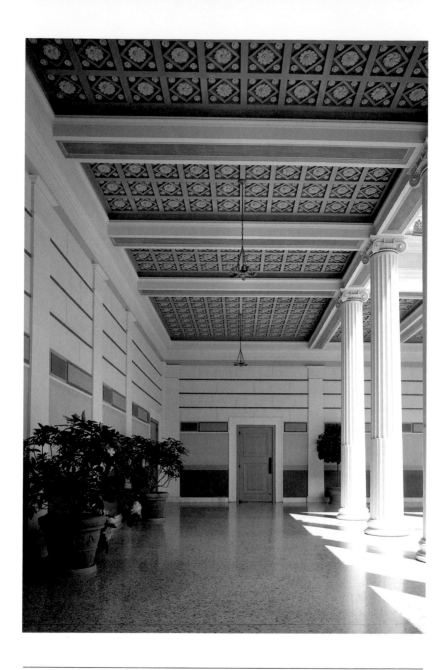

Copied from the walls of the large peristyle in the House of the Faun in Pompeii, the
decoration of the Inner Peristyle matches that of the Atrium. Thus the re-creations of
the oldest parts of the Villa dei Papiri are linked stylistically to one another in the
Museum. While in the ancient villa the false ashlars would have been made of
stucco, in the Museum they are made of molded plaster applied to concrete walls,
giving a similar visual effect. Ionic capitals atop graceful fluted columns surround the
Inner Peristyle Garden on all four sides.

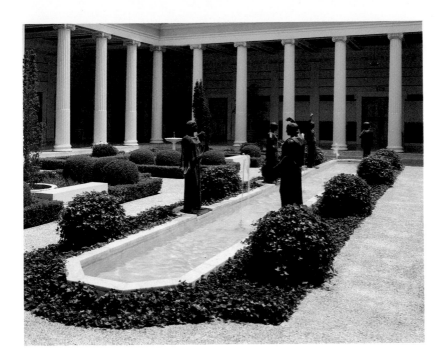

*The narrow pool of the Inner Peristyle Garden is guarded by five bronze statues of women. Most of the plantings are low and rounded and allow a clear view from one side of the garden to the other.*

dei Papiri, the villa's inner peristyle appears to have been their original setting, for they fit perfectly into the semicircular areas there. All four corners of the Museum's Inner Peristyle Garden embrace identical white marble fountains that were re-created from a description in Weber's excavation reports. The small plaster-relief floral coffers in the ceilings are based on stone coffers from a dismembered monument on the Street of the Tombs in Pompeii. The serene mood of the Inner Peristyle is enhanced by the muted colors used on the painted surfaces, all of which match the hues of weathered antique paintings.

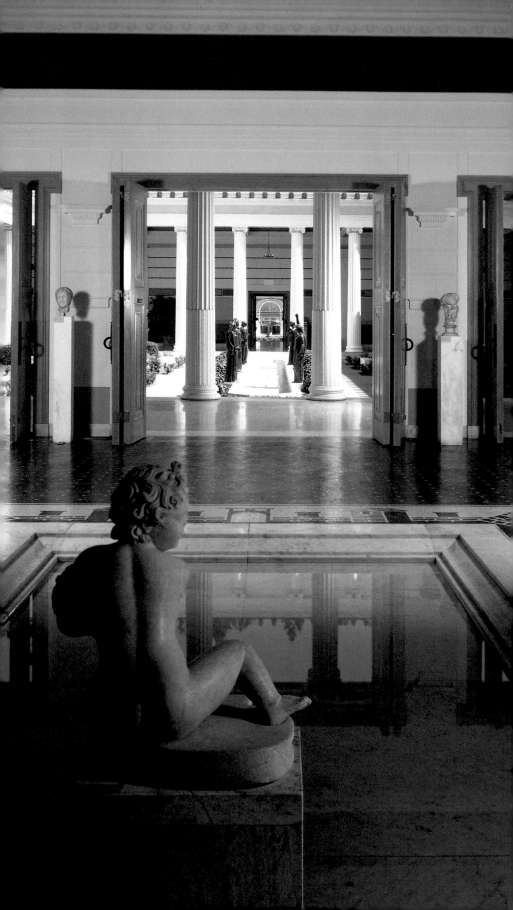

## ATRIUM

In the second century B.C., the atrium was the heart of a Roman house. In size and decor, the Museum's Atrium is a more exact reproduction of a typical Roman space than any other room in the building. It is two stories high, as were many second-century atria. The lower walls are decorated with simple but elegant plaster reliefs in the Pompeiian First Style, and imitate stonework in the atrium of the House of Sallust in Pompeii. The Atrium's upper walls consist of a false loggia with Ionic half-columns and latticed parapet, modeled on features in the atrium of the Samnite House, which was built in the second century B.C. The wooden coffers in the ceiling contain rosettes covered with gold leaf. The opening in the Atrium ceiling is covered by simulated alabaster panels and a metal grille for reasons of climate control and security. In fact such grilles occasionally were used in antiquity to keep out thieves. The lion-head drain spouts surrounding the grille were inspired by similarly positioned ones in the House of the Vettii in Pompeii.

In the Villa dei Papiri the atrium and most of the rooms surrounding the inner peristyle had mosaic floors. One excavation report describes the one in the atrium as having a frieze showing "in various colors some towers and other structures." In the Museum, only the Atrium has a mosaic floor. Done in black and white, it is modeled after a mosaic pavement that closely fits the description in the report but that was found in the House of Arius Diomedes in Pompeii. The doors of the *cubicula*—the villa's original bedrooms—on both sides of the ancient villa's atrium had been walled over by the time Vesuvius erupted in A.D. 79, and niches in these walls were used to display bronzes. In one niche were the eleven bronze tiger heads spouting water into a lead basin which formed the prototype for those decorating the central fountain in the Museum's East Garden. The small rooms off the Atrium re-create the appearance of these spaces when they were used as bedrooms in the second century B.C., and original frescoes and household objects from antiquity are displayed inside them.

Three of the spaces accessible from the Inner Peristyle on the Main Level deserve special mention, since their construction and decor highlight a variety of Roman building techniques.

---

*Looking across the pool in the Atrium toward the east, one can follow the main east-west axis of the Museum between the rows of bronze statues in the Inner Peristyle Garden to the mosaic grotto in the East Garden. The heads atop pedestals on either side of the doorway are from sculptures of the Roman period.*

---

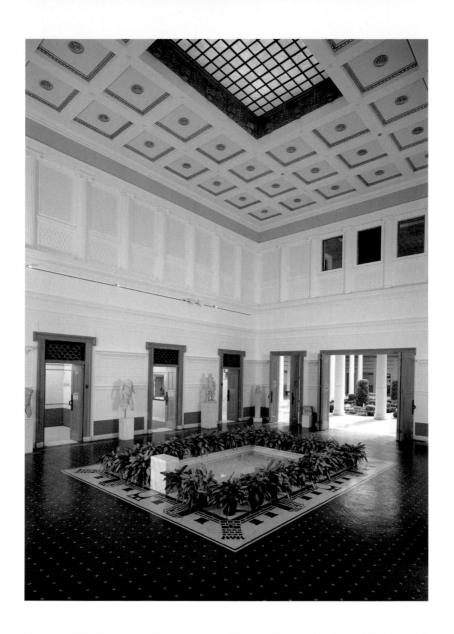

Important features of the Atrium's upper walls include engaged Ionic capitals topping short fluted columns, and false latticework below simple railings. The latticework motif recalls the painted fences in the West Porch and elsewhere in the Museum. Doorways below are framed by simple marble posts and lintels. Along the walls stand sculptures from the antiquities collection. The simple mosaic floor surrounds a rectangular pool. Through the door at the right the Inner Peristyle Garden can be glimpsed flooded with sunlight.

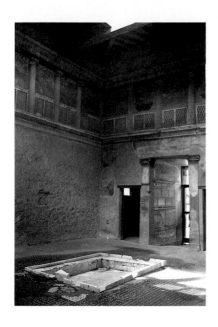

The organization of the Museum's Atrium and details of the decor of its upper walls recall the Samnite House in Herculaneum, illustrated here, which was built in the second century B.C. The Samnite House's shallow central pool and compluvium were characteristic features of atrium dwellings.

The Atrium floor was copied from one in the House of Arius Diomedes in Pompeii, shown at the right in an 1862 engraving. A shallow pool was substituted for the labyrinth pattern of the original. The floor, composed of numerous black and white tesserae, or very small tiles, was laid by hand.

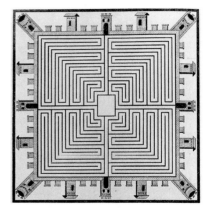

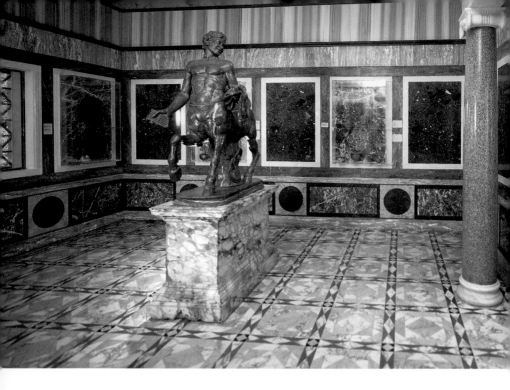

*Fourteen different kinds of marble, both ancient and modern, decorate the floors and walls of the Hall of Colored Marbles. All of the marbles used in the Museum come either from quarries used in antiquity or from destroyed monuments at ancient sites, and were fitted in patterns devised by Roman artisans and architects.*

## HALL OF COLORED MARBLES

By the first century A.D., wealthy Romans were using a great variety of colored marbles to cover floors and walls and to line fountains and pools. Marble was used either in large slabs or in small pieces that were combined to create intricate geometric patterns of different colors and shapes. To evoke the Romans' interest in marble as a decorative material with a wide range of colors and uses, the Museum's designers employed it extensively throughout the building, even though specific information about its use in the Villa dei Papiri is scanty.

The floor in the Hall of Colored Marbles reproduces one still in place in the House of the Relief of Telephos in Herculaneum and is cut entirely from salvaged ancient fragments. The wall paneling combines marbles and motifs from a number of ancient sources. The two pink Aberdeen granite columns in the room are from Lansdowne House in London, an eighteenth-century building designed by the Neoclassical architect Robert Adam; this granite is the only stone in the room from a source not known in Roman times.

## BASILICA

In the late first century B.C., the Roman architectural historian Vitruvius used the word *basilica* to describe a very large room that usually would have been a public hall but that occasionally was constructed as part of a sizable house. Such rooms may have been used as meeting halls or family chapels. Weber's plan of the Villa dei Papiri shows a room with an apse, or vaulted semicircular space, at one end and an anteroom with columns at the other; the Museum's Basilica is a plausible representation of how this space might have looked. Eight white marble columns divide the Basilica into a wide nave with two extremely narrow side aisles, a plan that was adopted by the early Christians for their churches. The unusual Corinthian capitals—carved in four different colors of marble—are modeled after one found in the garden of the House of the Deer in Herculaneum.

The intricate stuccowork on the barrel-vaulted ceiling combines details from several houses in Pompeii. The coffered panels are based on similar ones found in the House of the Cryptoporticus, while the acanthus scrolls along the sides were inspired by the ceiling in the Forum Baths. The acanthus motifs in the semidome over the apse were copied from a niche in the House of Menander. The floor is a replica, again using ancient marbles, of one known to have existed in the Villa dei Papiri; it includes Numidian yellow, *pavonazzetto,* and panels of green Egyptian granite divided by thin strips of *rosso antico.*

## TEMPLE OF HERAKLES

This circular, domed room is a reproduction (except for the floor) of an underground sanctuary found at Monte dell'Incastro, halfway between Rome and Tivoli, in an area where there were many sanctuaries dedicated to the worship of the hero/god Herakles. The Temple's circular floor is an excellent example both of the complex geometric patterns favored by the Romans and of the variety of different marbles which could be incorporated into one pavement. A replica of the floor that marked the rediscovery in the eighteenth century of the Villa dei Papiri, it consists of twenty concentric circles, each composed of triangles of Numidian yellow alternating with triangles of *africano* or Lucullan marble. The slab in the middle contains arrows of *rosso antico* on a background of Numidian yellow surrounding a center of green Greek porphyry. Thus the Museum's floor, with some four thousand pieces, uses the same kinds of antique marbles as the original in the Villa dei Papiri.

The Temple's unplastered walls, the patterned mosaics in the semidomes of the two niches, the mosaic ceiling, and the laurel wreath encircling the opening in the dome were reproduced as exactly as possible. The cult niche in the sanctuary had been ripped out, however, presumably by Christians, so it was necessary to design one for the Museum's Temple.

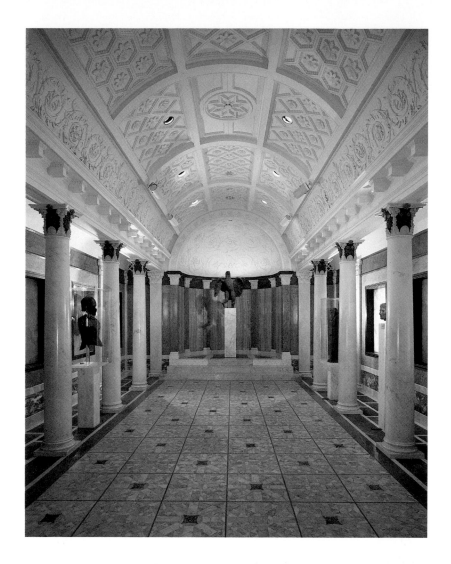

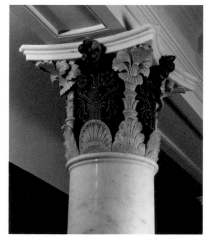

# UPPER LEVEL

# DIRECTORY

**GARDEN TEA ROOM**

**WEST GARDEN**

TO GARDEN TEA ROOM

**WEST PORCH**

**ANTIQUITIES**

ATRIUM

**BOOK-STORE**

**ORIENTA-TION THEATER**

**SOUTH PORCH**

**INNER PERISTYLE GARDEN**

**ENTRANCE VESTIBULE**

**FOUNDER'S ROOM**

**EAST VESTIBULE**

**EAST GARDEN**

**WEST TERRACE**

**PAINTINGS AND SCULPTURE**

**MAIOLICA AND GLASS**

**DECORATIVE ARTS**

**VESTIBULE**

**SOUTH TERRACE**

**INFORMATION CENTER**

**PHOTOGRAPHS**

**MANUSCRIPTS**

**DRAWINGS**

**BROWSING ROOM**

ANTIQUITIES

DECORATIVE ARTS

DRAWINGS

MAIOLICA AND GLASS

MANUSCRIPTS

PAINTINGS AND SCULPTURE

PHOTOGRAPHS

⊠ ELEVATOR

🍴 GARDEN TEA ROOM

? INFORMATION*

★ ORIENTATION

VIDEODISC

☎ TELEPHONES*

STAIRS

♿ WHEELCHAIR RAMP

WHEELCHAIR PATH

🚻 RESTROOMS*

*Also available on Lower Level (not shown), as are: direct-access phones to city taxi services; loading area for chartered buses; Auditorium; wheelchair-accessible restrooms and water fountains; and information post.

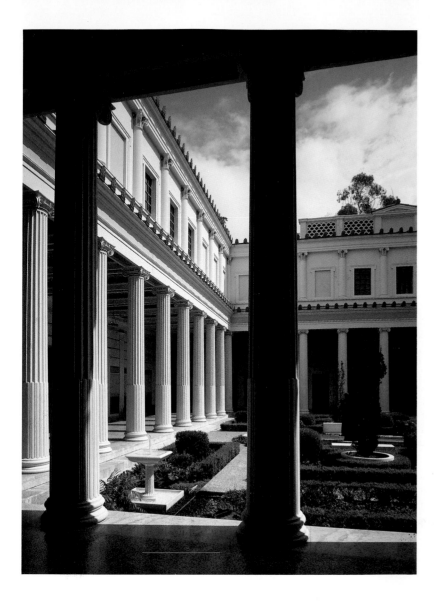

*Although it is not known whether the Villa dei Papiri had a full second story, many Roman atrium houses did. The upper story of the Museum, seen here from a corner of the Inner Peristyle, was copied from that of a house built during the second century B.C., the period during which the atrium and inner peristyle of the Villa dei Papiri were built. Engaged Corinthian columns flanking simple real or blind windows continue the vertical accents established by the Ionic columns below them, while rows of antefixes edge both the top and bottom rooflines, tying the two levels together visually.*

## A NOTE ON SOURCES

The sources for passages quoted in this publication are as follows: (p. 1), J. Paul Getty, "Foreword," in *The J. Paul Getty Museum Handbook* (Malibu, 1982), p. 1; (p. 3) (Didion), Joan Didion, "Getty's Little House on the Highway," *Esquire* (March 1977), p. 30; (Gebhard), quoted in Tod A. Marder, ed., *The Critical Edge: Controversy in Recent American Architecture* (Cambridge, Mass., and London, 1985), p. 120; (p. 4), Calvin Tompkins, *Merchants and Masterpieces: The Story of the Metropolitan Museum of Art* (New York, 1970), p. 108; (pp. 4, 7), Ethel Le Vane and J. Paul Getty, *Collector's Choice: The Chronicle of an Artistic Odyssey through Europe* (London, 1956), pp. 311, 312, 329; (pp. 15 – 19), Pliny the Younger, *Epistles* 4.20; and (p. 24), quoted in *The Age of Neo-Classicism,* exh. cat., Arts Council of Great Britain, London, 1972, p. xxxiv; Charles Nisbet, trans., *Goethe's Travels in Italy* (London, 1885), entry dated June 1, 1787.

## PHOTO CREDITS

All photographs reproduced in this book are by the Department of Photographic Services, J. Paul Getty Museum, with the following exceptions: Don Hull (cover); Julius Shulman (figs. 1 – 4, 22, 27, 29, 33, 36 – 40, 43, 46, 48, 50 – 56, 58, 59, 61 – 64, 68, 69, 71, 72, 75); Stephen Garrett (figs. 5, 6); Ecole Nationale Supérieure des Beaux-Arts (fig. 7); Caisse Nationale des Monuments Historiques et des Sites (fig. 8); Metropolitan Museum of Art, Cloisters Collection (fig. 9); Vladimir Lange (fig. 10); O. Louis Mazzatenta, © National Geographic Society (figs. 11, 30 – 32); Art Institute of Chicago (fig. 13); Art Museum, Princeton University (fig. 15); reproduced from *Pompeii 1748 – 1980: I tempi della documentazione* (Rome, circa 1981), p. 174, fig. 34c (fig. 16); Skulpturensammlung – Staatliche Kunstsammlungen Dresden (fig. 17); reproduced from J.-C.-R. de Saint-Non, *Voyage pittoresque, ou Description des royaumes de Naples et de Sicilie,* vol. 2 (Paris, circa 1782), pt. 2, frontis. (fig. 18); reproduced from A. O. Bayard, *Della antichità de Ercolano,* vol. 1 (Naples, 1757), frontis. (fig. 19); reproduced from C.-N. Cochin and J.-C. Bellicard, *Observations sur les antiquités d'Herculaneum* (Paris, 1755), p. 26 (fig. 21); Metropolitan Museum of Art (fig. 23); reproduced from F. Rehberg, *Drawings Faithfully Copied from Nature at Naples* (London, 1794) (fig. 24); Norman Neuerburg (figs. 25, 70); reproduced from M. Grant, *Eros in Pompeii* (New York, 1975), p. 46 (fig. 28); Lloyd K. Townsend, © National Geographic Society (inset, fig. 32); Jack Ross (figs. 41, 42, 44, 57, 60, 73); Anne Kresl (figs. 45, 65); reproduced from L. Barre, *Herculaneum et Pompeii,* vol. 5 (Paris, 1862), pl. 74 (fig. 66). Drawings for figs. 12, 14, 26 by Martha Breen.